Mary E. Lee

IMAGES of America
MOORHEAD

Terry Shoptaugh

Copyright © 2004 by Terry Shoptaugh.
ISBN 0-7385-3302-5

Published by Arcadia Publishing,
Charleston SC, Chicago IL, Portsmouth NH, San Francisco CA.

Printed in Great Britain.

Library of Congress Catalog Card Number: 2004105276

For all general information contact Arcadia Publishing at:
Telephone 843-853-2070
Fax 843-853-0044
E-Mail sales@arcadiapublishing.com
For customer service and orders:
Toll-Free 1-888-313-2665

Visit us on the internet at http://www.arcadiapublishing.com

Contents

Acknowledgments		6
Introduction		7
1.	How It Began	9
2.	Making a Living	21
3.	Making a Community	33
4.	A Volatile Environment	43
5.	New Challenges	53
6.	Hard Times	65
7.	War and New Prosperity	77
8.	Times Were Changing	91
9.	Ebb and Flow	105
10.	Moving Forward, Looking Back	117

Acknowledgments

My debts incurred during this project are numerous. Mark Peihl, Pam Burkhardt, and Lisa Vedaa of Clay County Historical Society were indispensable for their help in finding and identifying so many excellent images for this book. My assistant Korella Selzler was tireless in finding and scanning the images from our own collections. Darel Paulson, our university's Instructional Media photographer, deserves credit for additional images and for employing his expert eye with respect to the entire collection. Thanks also to Sandy Slater at the Elwyn B. Robinson Department of Special Collections, University of North Dakota, for permission to use an image, to Sharon Hoverson, Concordia College Library, for images from their archives, and to John Bye for images from the Institute for Regional Studies, North Dakota State University. Finally, thanks to Maura Brown, Arcadia's editor for this project, and to her staff, for their hard work and encouragement.

Photo Credits
Northwest Minnesota Historical Center, Minnesota State University Moorhead (NMHC)
Clay County Historical Society (CCHS)
Institute for Regional Studies, North Dakota State University (NDIRS)
Concordia College Archives
Minnesota Department of Transportation
Minnesota State Community and Technical College, Moorhead
Moorhead city government, various offices
Heritage-Hjemkomst Interpretative Center
River Keepers
Abby Sunde-Tow
Darel Paulson
Diane Wray Williams
John Borge and Eventide
Mrs. Roland Dille
Wayne Bradley and Eide Bailly

Introduction

The distinctive thing about so many Minnesota towns, Sinclair Lewis pointed out in an essay in the early 1920s, was how they could grow from "a wind-beaten prairie" into "a complex civilization" in the span of one or two generations. In the early 19th century, settlements sprang up on the lands that would become the southern part of the Minnesota Territory. They emerged almost overnight, as a collection of shacks and tents alongside an important river bluff or a falls or a trail that had been trod by French and Native American fur traders. Thirty years later, these pioneer villages were bustling communities with lighted main streets, busy business districts, and homes with indoor plumbing. By that time, hundreds of steamboats were plying the Minnesota and Mississippi Rivers; within another decade, railroads would begin to push into the western and northern parts of the state of Minnesota. It was during this latter phase of growth that Moorhead was born.

Moorhead owes its inception to the fact that engineers for the Northern Pacific Railroad chose one particular spot to bridge the Red River. From the very first, the town's fortunes and future were intricately tied to its location in the complex of American transportation and commerce networks. Moorhead came of age during one of the most explosive periods of American technological innovation. New inventions and industries came to life, creating new opportunities and new fortunes. All too soon many of these were outdated by yet newer technologies and industries. Like those living elsewhere, the people of Moorhead struggled to keep up with the dizzying pace of change only to see the pace accelerate ever faster. The impact of seemingly endless change can be discerned in the photographs in this collection.

And yet continuity can also be found in the images of Moorhead and its history. As the seat of a county made up of smaller towns and farms, Moorhead has always been very much a part of the culture of rural America. Over the decades, its economic health has risen and fallen with the fortunes of the farms. Moorhead's cultural and social life has likewise reflected the culture of rural, small town America. Many of the images in this collection show the resilience of this tradition.

When Sinclair Lewis died in 1951, many of the towns in Minnesota, and elsewhere in rural America, were feeling the first effects of protracted and painful decline. The farming population, lured away from the land by economic necessity and the allure of urban life, dropped steadily. By the late 1970s it was possible for fewer farmers to manage more acreage and extract more production from the land than ever imagined by their forefathers.

Moorhead now is a city of some 30,000 people and part of a much larger metropolitan area that spans across the border between two states. But with the continued drop in rural population, its residents worry about the long-term future of the community. In an era of international trade and high-speed Internet access, city leaders scramble to seize every opportunity to multiply and diversify the community's potential. At the same time, the residents of Moorhead continue to extol the values of the small town that they want their community to be. Looking ahead in hope and concern, they also look back for reassurance and inspiration; the interplay of change and continuity goes on.

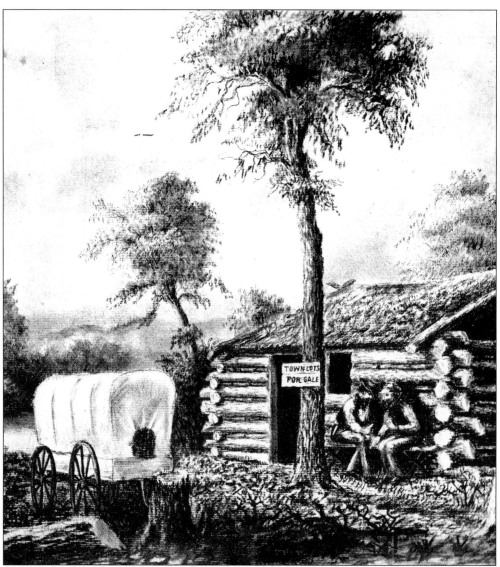

This image is an excellent example of some of the uncertainty that is often present in pioneer history. Moorhead photographer Ole Flaten made a photograph of this sketch sometime during his long career, and said late in his life that an unknown artist made the sketch about 1867. The sketch depicts Burbank Station, one of a series of stage and freight stops built by the Burbank, Blakely and Merriam Stage and Freighting Company, which maintained a freight line that stretched from St. Paul to the Red River. The details about the building's origin are unclear: Lewis Lewiston, an employee of the Freight Company, either built this log structure in 1859 or took it over from an earlier occupant. He operated it as a way station and inn for travelers and freight haulers. The station remained in operation until 1862, when the "Dakota Incident" forced the company to abandon it. Two or more early settlers then lived in the structure when the town of Moorhead was established on the same ground. The log building was demolished as the town grew, but some of the logs from it were salvaged and today they are part of a replica cabin that now stands in Moorhead's Woodlawn Park. (CCHS).

One
How It Began

The city of Moorhead today rests on land that once was the bottom of an enormous glacial lake. Formed about 14,000 years ago and existing for nearly 4,000 years, glacial Lake Agassiz (named for a 19th century geologist) was larger than the combined area of the current Great Lakes: its 110,000 square mile area covered parts of northern Minnesota, the eastern part of North Dakota, and much of Canadian Manitoba.

When Lake Agassiz drained as the last ice age ended, the Red River Valley emerged from the lakebed. The silt-heavy soil from the lakebed was excellent for farming and became the region's most precious resource once full-scale settlement began.

Native Americans inhabited the valley for centuries before Europeans first set foot in the area. French and British traders traveled along the river and its tributaries in the 17th and 18th centuries, mostly for the purpose of obtaining furs to sell in Europe. This trade continued into the 1800s, with a few hardy individuals settling down to live their lives in the valley. But large-scale white settlement did not begin until after the American Civil War, when a railroad was built from Minneapolis to the Red River.

Barely 10,000 years old, the Red River has numerous twists and bends and a shallow riverbed that is prone to frequent silting and flooding. Its south-to-north current facilitated trade with Canada, but for western movement it had to be bridged. (NMHC.)

Trails along the Red River were being used by the 1830s to carry on a brisk trade in furs and manufactured goods between St. Paul and the Canadian colonies to the north. Pulled at first by oxen, later horses, the carts were still in use when Moorhead was founded, but the riverboats and the railroad put an end to them before 1880. (NMHC.)

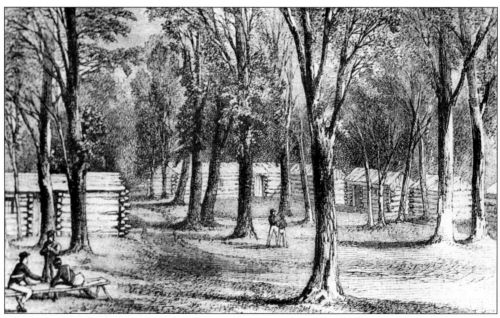

The U.S. Army built Fort Abercrombie on the west side of the Red in 1857, partly to protect settlers from Dakota (Sioux) bands on the plains and partly to establish the federal government's presence in the region. Anticipating widespread settlement in the area, the Minnesota legislature established a county along the Red in 1858. (NMHC, sketch from *Harper's New Monthly*, September 1859.)

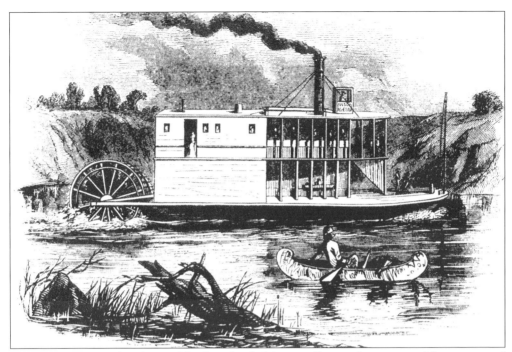

Mississippi River pilot Anson Northup hauled his small steamboat across Minnesota and launched it on the Red in 1859. The small boat plied the river for only two years before sinking, but this supplement to the cart trade stimulated interest in the valley as a profitable site for trade and settlement. (NMHC, sketch from *Harper's New Monthly*, August 1860.)

Captain Mahoney was one of the later pilots on the Red River. Navigating the Red was a challenge, another traveller calling it "very tortuous in its course, its length being about twice that of straight lines. The current is sluggish and the water is very muddy" and prone to silting. (NMHC, quote from *Harper's New Monthly*, August 1860.)

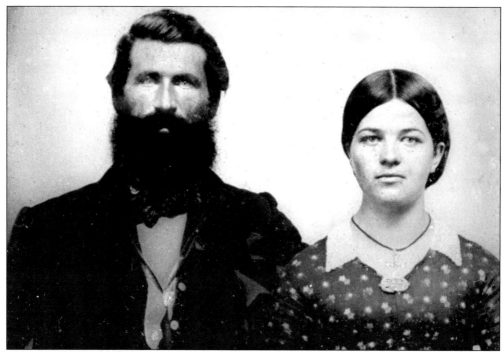

Randolph Probstfield (pictured in what is likely his 1861 wedding photograph with his wife, Catherine) came to the valley in 1859 and accepted a job at the Hudson's Bay trading post in Georgetown. Purchasing a small piece of land from the company, he began experiments to discover which crops could successfully be grown in the soil. (CCHS.)

The land was still covered largely by prairie grass, with trees only near water. "Prairie-grass and western winds, blue sky and bluer waters, vast horizons and flying clouds, and wanton interchange of belted light and shadow—they all filled us, if not with a new delight, yet with one which never grows stale from experience," explained writer Bayard Taylor on his visit to the Red River Valley in July of 1871. (NMHC.)

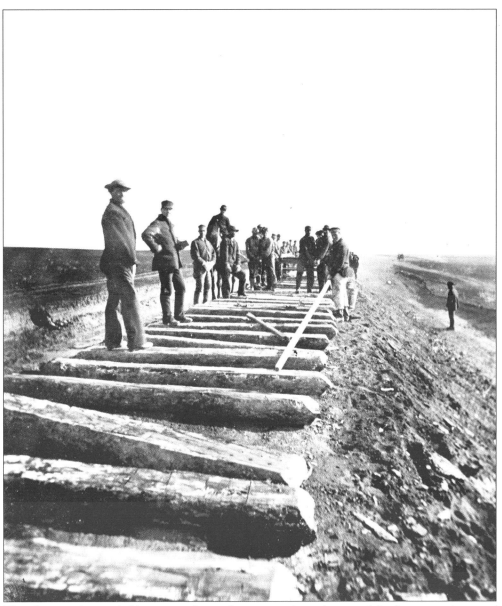
This photograph is probably a copy of an earlier print and may be one of the few extant images of a Northern Pacific Railroad track-laying crew as the rails approached Moorhead in 1871. (CCHS.)

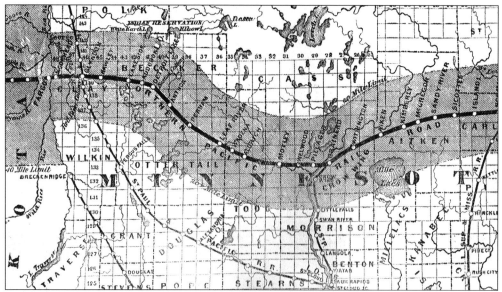

This map is from a Northern Pacific Railroad promotional pamphlet, showing the route for its line from Duluth to the Pacific Ocean. The Northern Pacific's engineers would choose the site for crossing the Red River in 1871, prompting speculators to stake claims along the river in hopes of making a killing. (NMHC, map from Northern Pacific Railroad Pamphlet.)

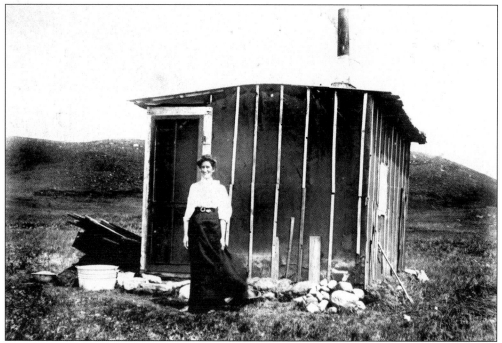

A claim shanty and its inhabitant, in Clay County c. 1871, are shown in this image. Whether this woman planned to homestead or was speculating on land value is uncertain. In order to mislead speculators near the Red River, the Northern Pacific's planners made a show of examining a site a few miles north of their actual choice for bridging the Red. After work began at the real site, claimants abandoned the false site, giving it the name "Bogusville." (NDIRS, 328.1.8.)

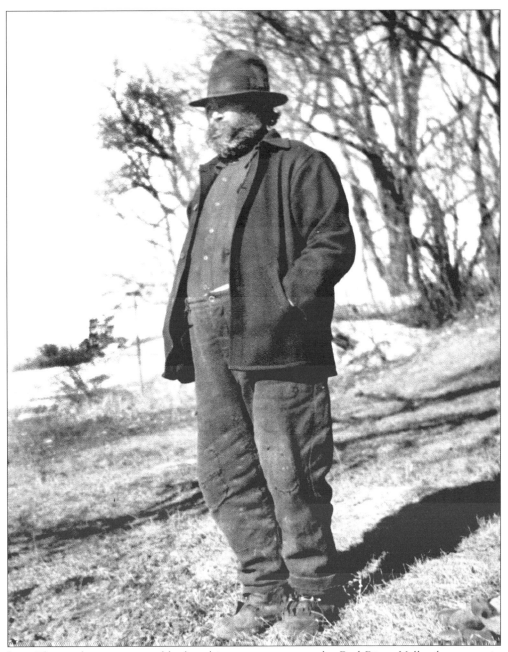

Levi Thortvedt, nine years old when his parents came to the Red River Valley by wagon in 1870, recalled the founding of Moorhead: "Moorhead was just a tent city [at first] but it did not take long before the Northern Pacific had a depot and warehouse up and other frame buildings sprang up rapidly." (NMHC.)

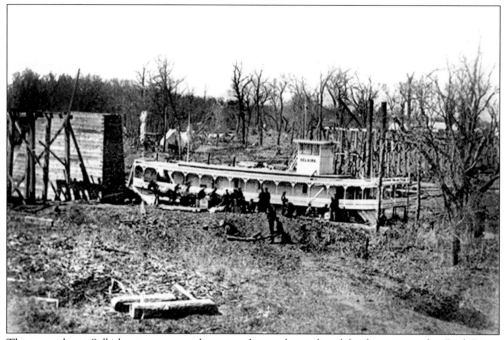

The steamboat *Selkirk* passes as work proceeds on the railroad bridge across the Red River during spring of 1872. Moorhead was being built behind the photographer while Fargo was going up across the river. (CCHS.)

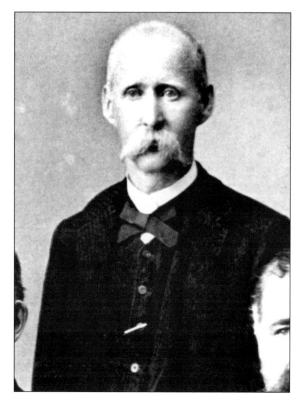

"I well remember the first winter here," James H. Sharp recalled of 1872. "Our only shelter was a tent, and that not lined; there was not even a ceiling in any of our abodes. Mattresses were laid on the rafters, and the mattresses were straw ticks. We had to go to Probstfield's four miles for our meals at first." (NMHC.)

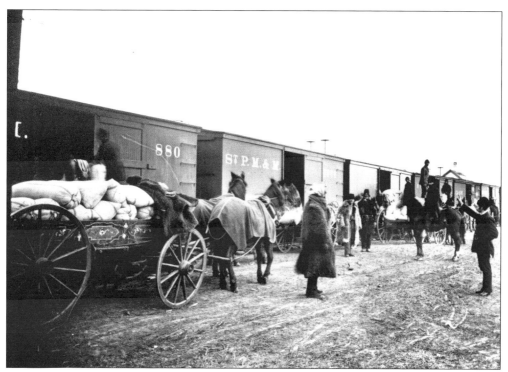

Here grain sacks are being loaded by hand, c. 1880. "This region will compare favorably to other sections of the country in the production of wheat, oats, barley, buckwheat and potatoes," declared a Northern Pacific land brochure. (CCHS.)

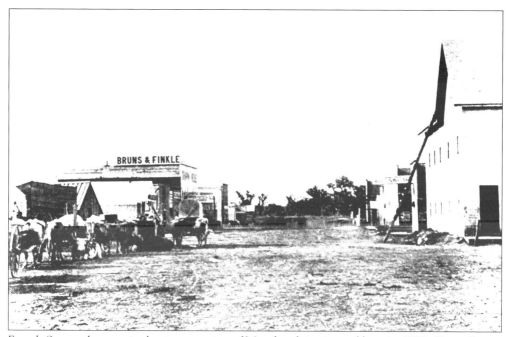

Fourth Street, the premier business section of Moorhead, is pictured here in 1873. Henry Bruns, co-owner of Bruns and Finkle, became the first mayor of Moorhead. (NMHC.)

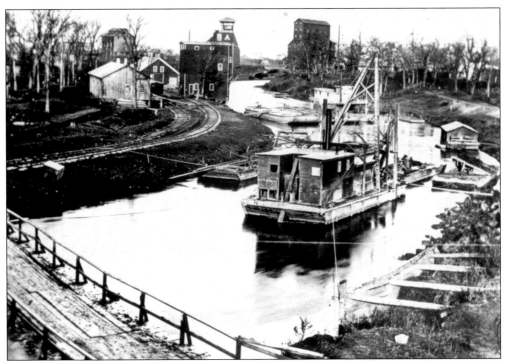

This image is of the riverfront, with wagon bridge, in 1879. The narrow width and shallow depth of the river required constant use of dredge boats, like the one in this photograph, to keep a channel open. (NMHC.)

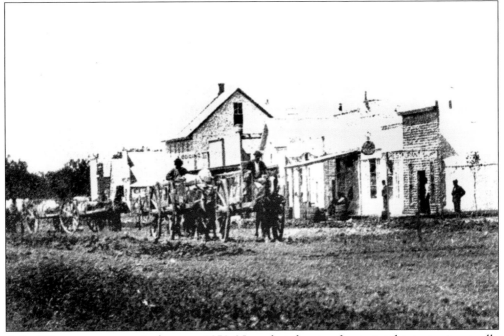

A Red River cart caravan is shown c. 1872. Note that the storefront at right center is actually the façade of a tent. Steamboats and the railroad soon made the carts obsolete. (NMHC.)

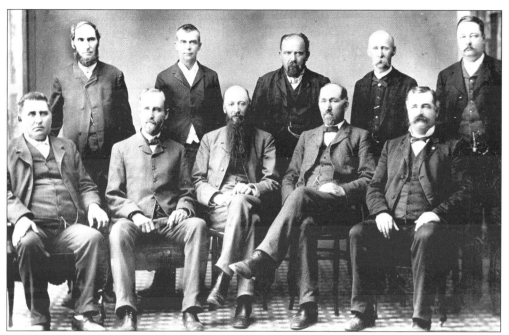

Moorhead's most prominent businessmen and civic leaders formed the Red River Congress. Part chamber of commerce, part social club, the Congress promoted the town, raised money for water wells, supported the exclusion of Chinese immigrants, and advocated moving the nation's capital to St. Louis. Among the Congress members seated above are James Sharp (back row, second from right), Henry Bruns (front row, center) and Solomon Comstock (front row, second from right). (NMHC.)

Ole Flaten arrived in Moorhead soon after it was founded. Although he was the town's auditor and postmaster at various times, his most important contribution was photographing the growth of Moorhead over a period of nearly 50 years. (NMHC.)

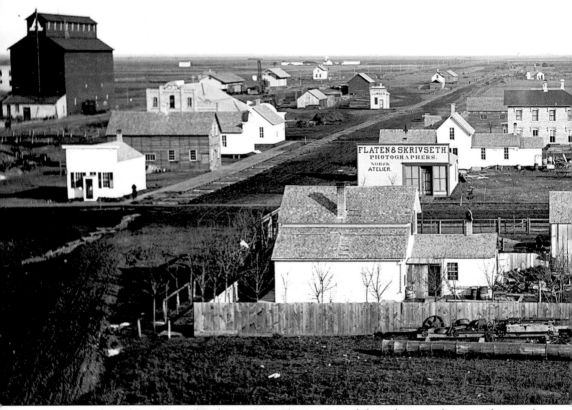

This is the edge of Moorhead in 1879. Flaten opened his photographer's studio in the prominently marked building. The building had served as the town's post office for nearly 10 years. (CCHS.)

Two
MAKING A LIVING

Moorhead was named in 1871 in honor of William G. Moorhead, one of the directors of the Northern Pacific Railroad. Moorhead the man seldom set foot in the town. But the Northern Pacific Railroad that he represented retained an enormous influence on the city for decades. Most of the goods and resources that Moorhead needed in order to grow came by way of the railroad. Almost all of the goods produced in the town, and much of the grain grown by farmers in the surrounding area, were shipped out by the railroad. The railroad owned the bridge spanning the Red River, and the locals could not use it without special permission from Northern Pacific officials. Not surprisingly, Moorhead officials were quickly interested in ideas for attracting a competing railroad to the region.

With its location and its importance as the county seat, Moorhead immediately became a vital market and service center. As such, it quickly attracted a larger number of businesses than most other towns in the region. How well it would do in the long run, however, depended on the ability of its city leaders to exploit every opportunity to the fullest.

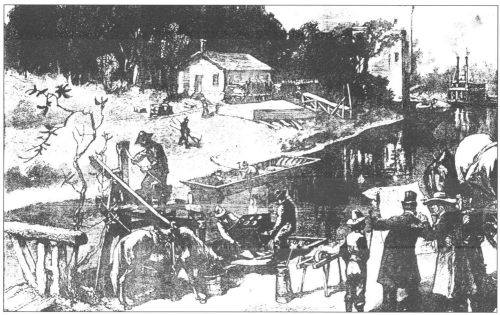

This woodcut of Moorhead is from the *Harper's Weekly* issue dated August 27, 1881. The wagon bridge glimpsed in the left edge of the illustration was first built in 1874. Its surface was so close to the water that it was damaged by ice many times. The city could afford to repair and maintain the bridge by charging tolls. Moorhead and neighboring Fargo did not join forces to build better passenger bridges until the mid-1880s. (NMHC.)

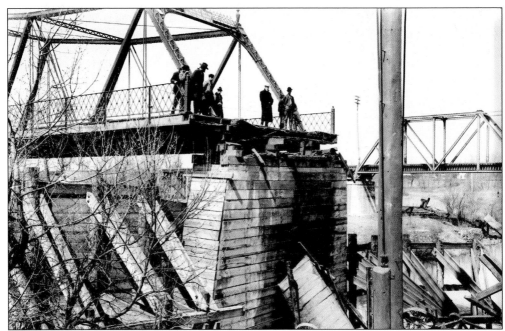

Bridge maintenance was an ever-present challenge. A threshing rig being hauled across the Old South Bridge in 1902 fell to the embankment below when one of the spans gave way. The horses were killed, the driver injured, and the city of Moorhead had to pay a judgment of $9,000 for the damages. (CCHS.)

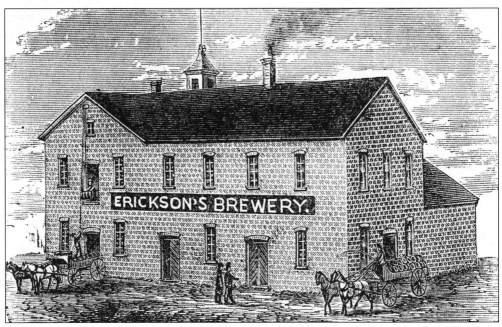

Rather than rely entirely on outside suppliers, Moorhead businessmen built facilities for manufacturing whatever it could locally. A local brewery was in business within a year of settlement. This woodcut from an 1883 promotional pamphlet featured Erickson's Brewery, a local beer-maker for several years. Liquor sales became a big business in early Moorhead. (CCHS.)

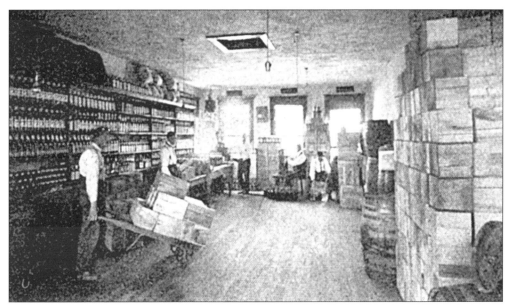

This image shows the interior of the warehouse for Diemert's Wholesale Liquors. Diemert's was a latecomer among the many saloons and liquor businesses that proliferated in Moorhead. Moorhead's Fourth Street, with its saloons and gambling houses, became notorious. In 1878, a Minneapolis newspaper referred to Moorhead as "the wickedest city in America." (NMHC.)

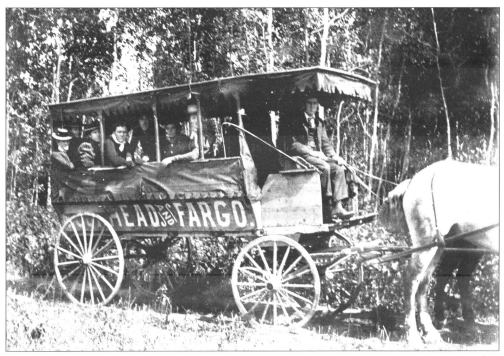

One enterprising business born of the saloons was the "jag wagon," a carriage service that transported Fargo residents and visitors across the river to Moorhead's saloon district. Several Minnesota towns along the Red River benefited from North Dakota's adoption of alcohol prohibition in 1889. (NMHC.)

As Clay County's first prosecuting attorney, Solomon Comstock (shown here c. 1930) had mixed feelings about the era of the saloons. "There were always many Moorhead citizens who were against the liquor traffic," he explained, "but on the other hand if they took the 47 saloons out of Moorhead, what was left? Moorhead's great problem was to be pure or prosperous." (NMHC.)

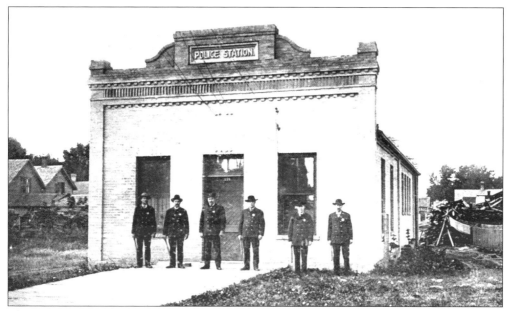

The saloons kept Moorhead's small police force busy. When one of the saloon owners killed two men in an argument, Comstock prosecuted him for murder and the man went to prison for life. Another "reckless character," John Walters (alias Blinky Jack), was arrested for shooting at several men on Fourth Street and served five years in prison. (NMHC.)

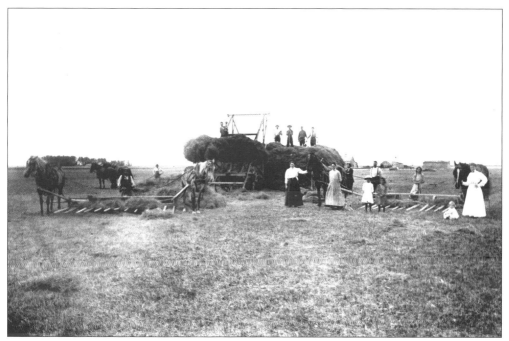

Agriculture was Moorhead's best source of income. Many of the farmers in Clay and surrounding counties stored and shipped their grain out of Moorhead and purchased their necessities in Moorhead's shops. Many merchants maintained detailed accounts for selling goods on credit against future harvests. (NMHC.)

Although much of the land was open prairie, clearing any brush or trees often required enormous labor. Plowing under the dense prairie grass was also difficult work. (NMHC.)

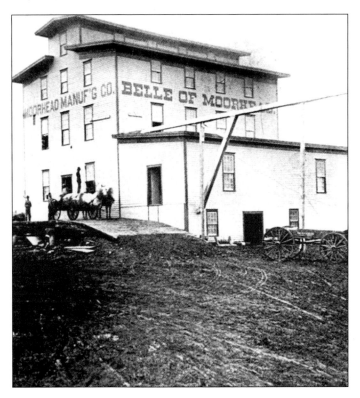

The Moorhead Manufacturing Company was one of the earliest flourmills in the town. Later mills would have electric lights and steam-powered elevators, but at first it took hand labor to unload the wagons and haul the grain sacks. (NMHC.)

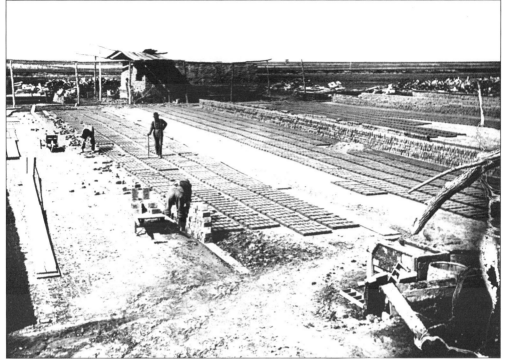

This is an image of the Lamb Brothers brickyard taken in the 1880s. Wooden chimneys in early homes and businesses resulted in so many fires that the *Red River Star*, Moorhead's first successful newspaper, charged that only a "base poltroon" wouldn't pay for a brick chimney. (CCHS.)

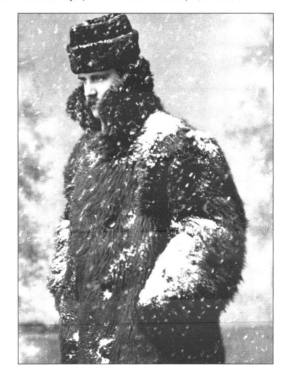

Benjamin F. Mackall arrived in Moorhead in 1873 and became the town's first pharmacist. He posed in his buffalo coat in a photography studio for this shot: the snow was actually powder. But during his first winter in Moorhead he frequently awoke to find ice on the walls of his room and his top blanket stiff with frost. (NMHC.)

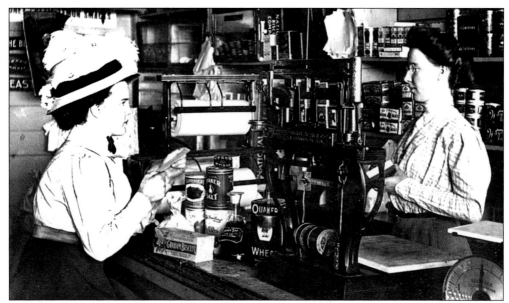
In this posed photograph of a typical general store, a discerning eye can notice brand name products such as Quaker Wheat cereal. By the end of the 19th century, consumers, even in the smallest towns, were demanding brand name foods, clothes, and other items. Merchants in Moorhead placed ads in the local newspapers to announce that they carried the most popular brands. (NMHC.)

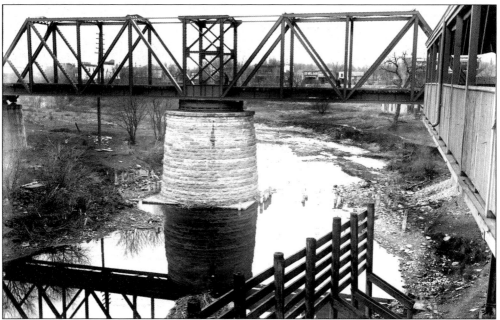
River transportation grew with trade, as did the size of the riverboats. In the 1880s, this bridge was constructed with a geared turntable so that the bridge could rotate open for larger boats. But it was hardly used before the railroads began to supplant the river trade. No photograph has ever been located of the bridge when open; this shot is from 1910, when a drought reduced the water level significantly. (CCHS.)

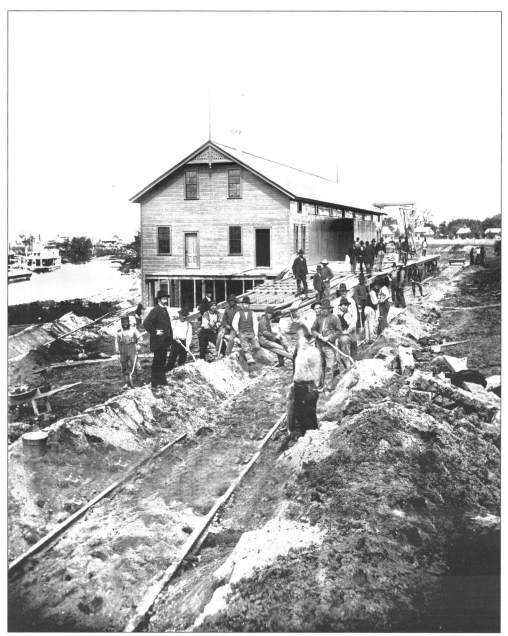
Workmen are busy building the Seymour-Sabin farm machinery construction plant and warehouse, at Center Avenue, in this 1880 image. The Seymour-Sabin plant built and sold its own farm machinery, and also sold machinery from other manufacturers. (CCHS.)

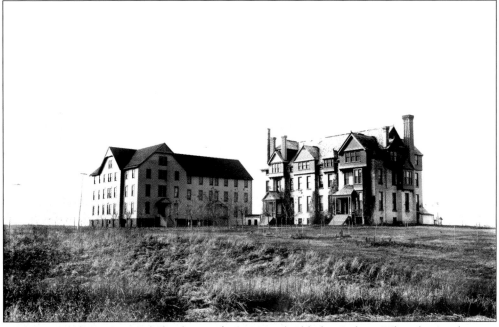

In 1882, city businessmen helped raise $25,000 to build the Bishop Whipple Academy, a private college. The academy was a financial failure by 1887, but the experience fueled the city's efforts to secure another college in Moorhead. The Whipple school later became the site for Moorhead's Concordia College. (CCHS.)

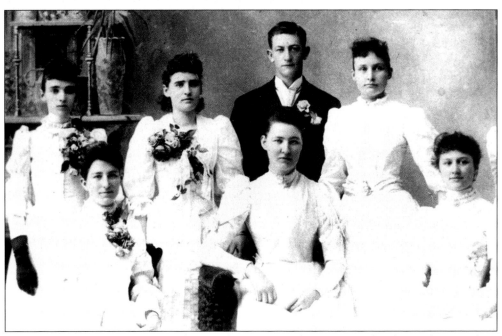

Solomon Comstock, having moved on to the State Legislature, secured a charter for a teachers college in Moorhead. Moorhead Normal School graduated its first class, whose seven members pose for this shot, in 1890. (NMHC.)

Most of the retail businesses in Moorhead were locally owned and operated. Emil Weingarten opened his clothing store in Moorhead in 1904. In 1917, he moved the store to Fargo. The store remained in business, in family hands, until the 1960s. (NDIRS, 328.1.20.)

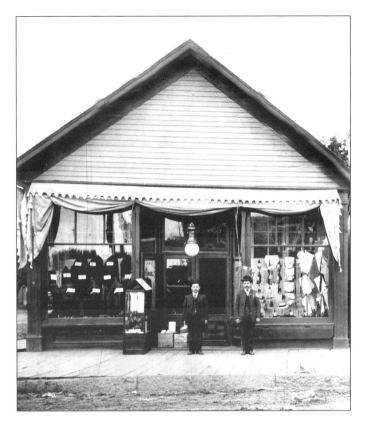

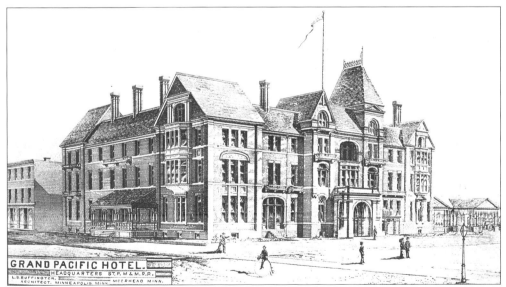

The first hotel in Moorhead was a two-story frame building with barely a half-dozen rooms. But by the late 1880s, prosperity in the city was reflected in such edifices as the Grand Pacific Hotel, where the weary traveler could dine on aspic shrimp, tame goose stuffed with apples, and chocolate cream fritters. (NMHC.)

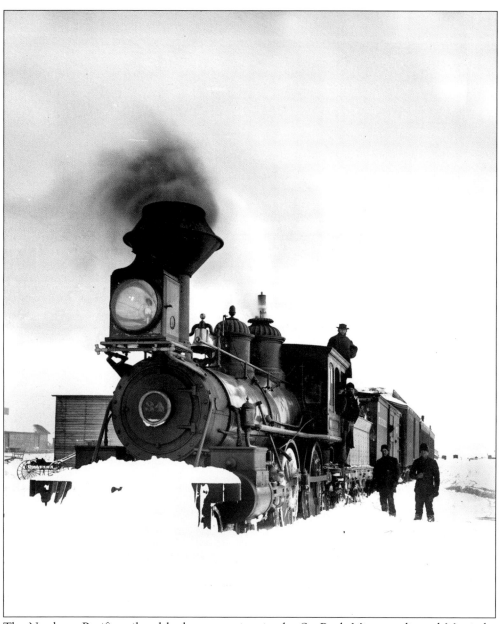

The Northern Pacific railroad had a competitor in the St. Paul, Minneapolis and Manitoba Railroad. This locomotive is believed to be the first to bring an SPM&M train to Moorhead, in the winter of 1880–1881. Rather than compete in the drive west across the sparsely settled American plains, the entrepreneur James J. Hill built the SPM&M toward already-settled Canadian towns in Manitoba. He won a lawsuit against the Northern Pacific Railroad in order to cross its line east of Moorhead. Only after amassing profits from Canadian and Minnesota trade did he build westward. (CCHS.)

Three
MAKING A COMMUNITY

Moorhead grew rapidly in its first three decades. The town's leaders for a time expected that it might become a larger city than its neighbor across the Red River. Thus, when Fargo proclaimed itself the "Gate City," Moorhead, not wishing to be outdone, took the name the "Key City."

But it took more than a catchy slogan to turn a frontier settlement into a modern American community. In order to keep growing, Moorhead needed to put on the garb of civilized society: the decent streets, good water, electricity, reliable medical care, and other implements of American progress. The population turned to building a cohesive social fabric, a difficult task when ethnic differences were more marked and when even the church one attended was often determined by the language in which the services were conducted. Ultimately, the sense of community was most strongly forged by the common experiences of the citizens.

Moorhead and its neighboring towns were true ventures into the wilderness. The railroads could bring in needed goods and carry out the bounty of the land, but it was up to the residents themselves to build the services that made a stable community. (NMHC.)

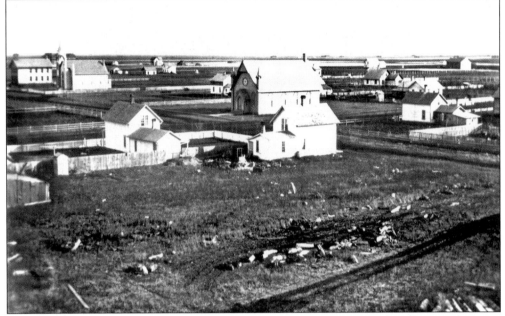

Pictured here is Moorhead in 1879, before such civilized amenities as sidewalks, paved streets, or indoor plumbing were implemented. Heat came from wood-burning stoves, homes and businesses were lighted with oil or kerosene, water was usually hauled rather than pumped, and mud ceased to be troublesome on only the coldest days. (NMHC.)

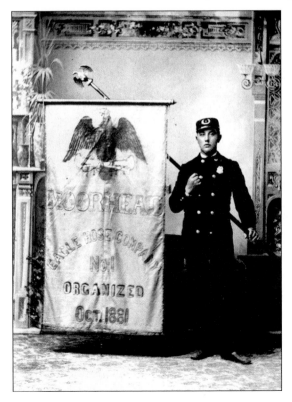

Moorhead did not organize an effective fire department until several years after the town was established. It is unclear if this studio photograph was taken in 1881 or later, to commemorate another special event for the Eagle Hose Company. (NMHC.)

Building a civil society was a challenge. The sign at the left of the stage in this entertainment hall reminds all the guests that "Spitting on the Floor is Bad Form." (NMHC.)

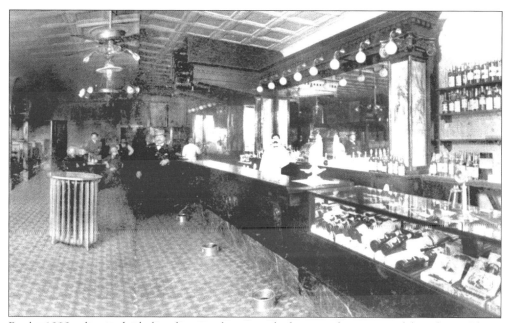

By the 1890s, the city had placed stricter limits on the hours and activities of the saloons. Places like Rustad's, seen here c. 1906, remained popular and profitable, but these establishments were tamer than the wide-open "dens of iniquity" that had existed 25 years earlier. (CCHS.)

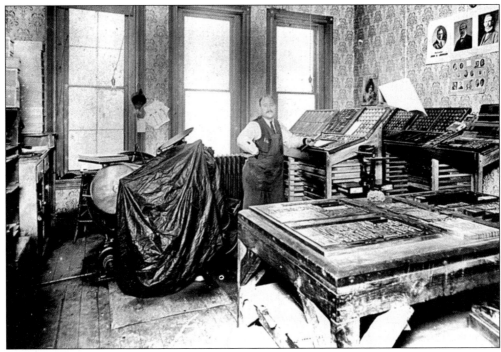

Ernest Melander, the publisher and editor of the *Moorhead Citizen*, campaigned for civic improvements, but defended the saloons vigorously. He fought every effort to impose prohibition in Clay County. Despite these efforts, the residents voted to make Clay a dry county in 1915 and the 31 saloons then in Moorhead closed their doors. (NMHC.)

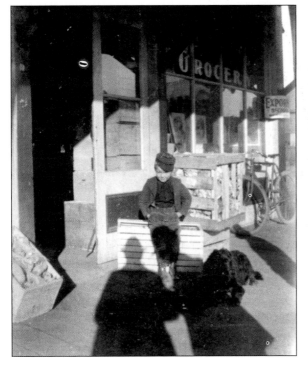

Protection of children was one of the strongest arguments for moral improvements. Moorhead churches and parents campaigned vigorously for prohibition and for more money for schools. Progress in both areas was slow until the turn of the century. (NMHC.)

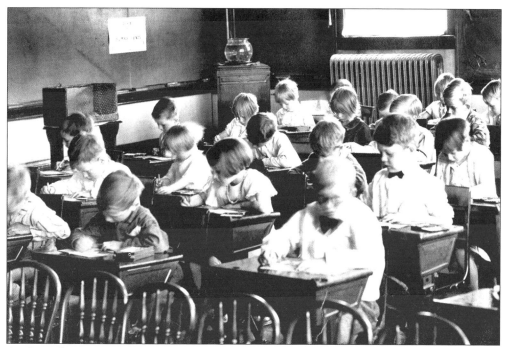

Quality education, wrote one of Moorhead's teachers, required "proper lighted, heated, and ventilated rooms; apparatus and books must be provided, and the right subjects of instruction must be selected." (NMHC.)

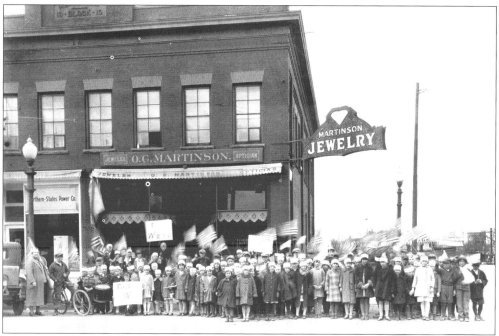

In 1916, children from the First Ward School, led by their teacher, Nelly Hopkins, turned out in force to urge voters to pass a bond issue for a new school. The sign close to the center of the group, partly obscured by the waving American flags, reads "We Need a New School." (NMHC.)

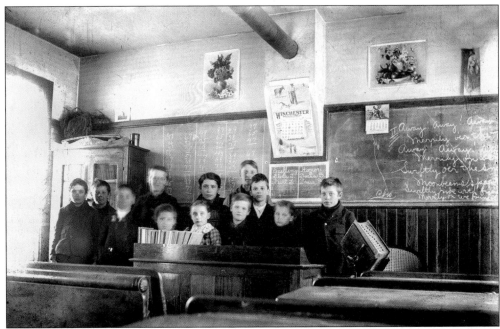

Both the Moorhead Normal School and Concordia College trained many of the region's teachers. Many, if not most, of the grade school teachers in the region's rural schools, like this one near Hawley in 1901, were graduates of these two Moorhead colleges. (CCHS.)

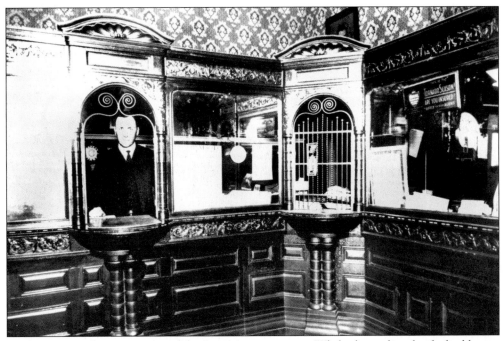

Banks were another major part of the growing community. While the earliest banks had begun as little more than storefronts, the successful ones became respectable cornerstones of the business district. Moorhead State Bank's interior, c. 1910, conveyed a reassuring image of prosperity and stability. (NMHC.)

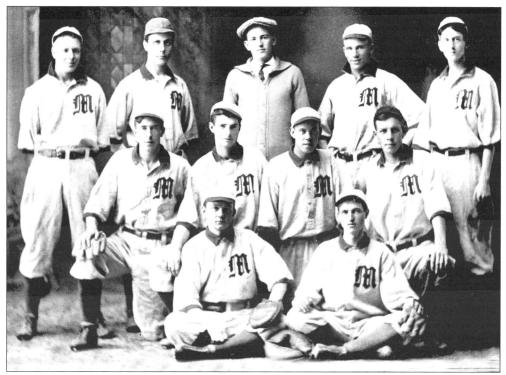

Local pride is evident in this photograph of the 1911 city baseball team. By defeating Fargo in the inter-city championship, Moorhead residents won some bragging rights in the friendly rivalry that existed between the two communities. (NMHC.)

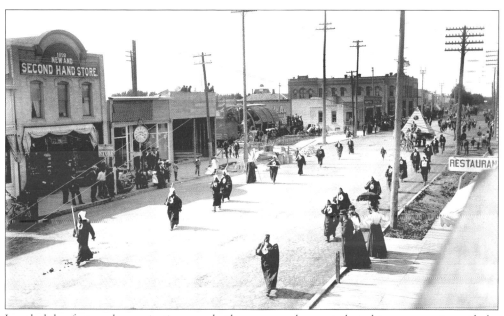

Local clubs, fraternal organizations, and other groups also contributed to community pride by raising money for special causes and promoting local activities. One such group, the marchers in this 1897 Shriner parade on 4th Street, was known as the Hoo Hoos. (CCHS.)

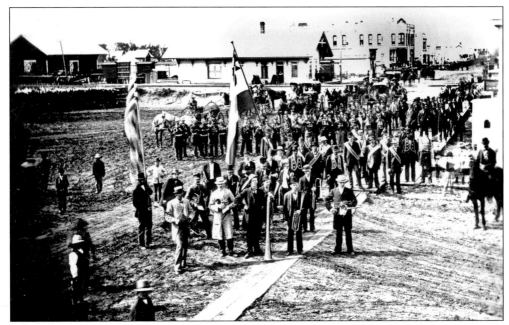

Norwegian immigrants worked hard to assimilate themselves into the dominant American culture. But they also held fast to their traditions, maintaining Norwegian-language newspapers for several decades and celebrating traditional holidays. This is a parade commemorating Syttende Mai in 1880. (CCHS.)

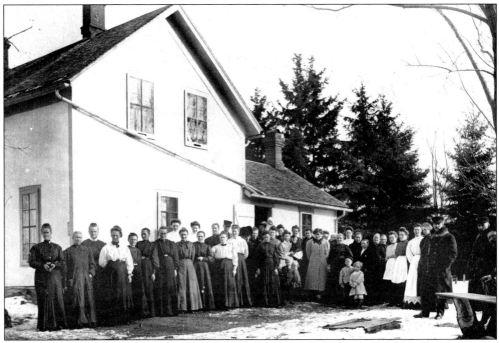

Women's organizations, usually connected to churches and immigrant societies, played a significant role in building ties between the new Americans and the established community. This particular group is a "kvinde førening," Norwegian for women's society. (NMHC.)

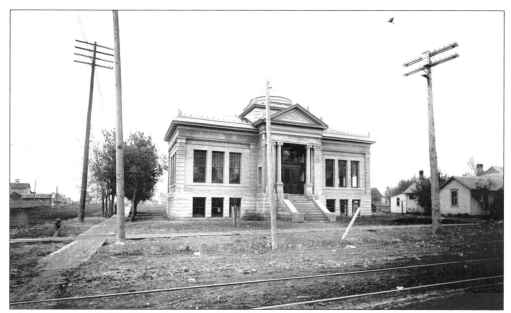

The Women's Club of Moorhead, established in 1893, had dedicated itself to improving the literary and cultural climate of the community. In 1904, the club persuaded the City Council to establish a library fund, and then obtained a $12,000 donation from Andrew Carnegie for the purpose of building the library. The new Carnegie Library opened in 1906 on the corner of 6th and Main Street. (CCHS.)

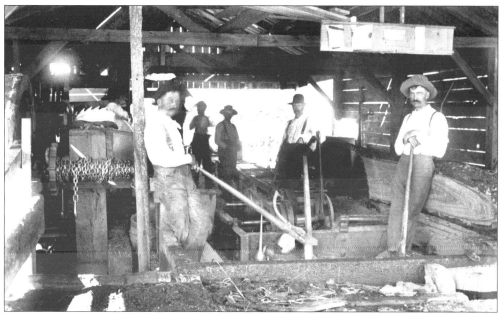

Although they made up a large segment of the regional population, farm laborers were often regarded as "outsiders." Newspapers in Moorhead often identified lumbermen or seasonal farm workers, who came to the area during spring planting or fall harvest, as "troublemakers" (not least because some of them tried to persuade co-workers to join the International Workers of the World). But laborers were in demand and their spending was always welcomed. (NMHC.)

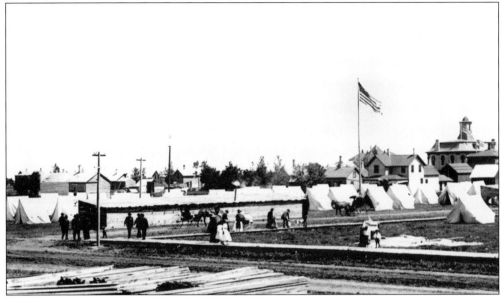

A more subtle aspect of Moorhead's sense of community was the feeling of shared experiences and common history. In 1890, Civil War veterans from the plains gathered in Moorhead for a Grand Army of the Republic camp reunion. Some of the earliest community leaders had served in the Union armies. (CCHS.)

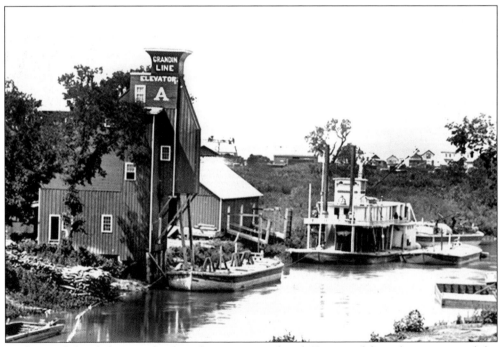

Dealing with local changes also forged a community bond. Fewer and fewer boats traversed the river and old timers mourned the decline of the trade. When the Army Corps of Engineers announced about 1915 that it would no longer dredge the river channel, the local press called it "the end of a colorful era." (NMHC.)

Four
A VOLATILE ENVIRONMENT

The Red River Valley is, in reality, the bed of a glacial lake, surrounded by a fairly level plain in the center of a huge continent, a situation that makes the valley subject to extreme swings in weather. Winter temperatures can fall to minus 40 degrees Fahrenheit in the winter (as much as minus 70 with wind chills); while summer temperatures can climb to as high as 115 degrees Fahrenheit. The annual rainfall is generally enough to sustain prairie grass, and thus permit crops of small grains. But droughts can and do occur, with devastating effects. The Red and the smaller rivers that flow into it are very young in geological terms, and capable of frequent flooding. Then there were the usual problems associated with high winds and sudden frosts. Finally, there is that loathsome pest the mosquito.

It is perhaps little wonder then that, while archaeological studies indicate that various groups of Native Americans inhabited the Red River Valley over several thousand years, they also suggest that seldom did Native Americans attempt to live near the Red River year round. This was the land that the pioneers set out to tame and make bountiful, and that their inheritors have all too frequently had to do battle with in order to survive.

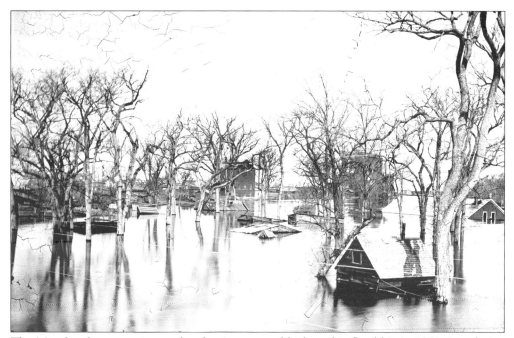

The Moorhead community was barely nine years old when this flood hit in 1881, inundating large parts of Moorhead, Fargo, and many other river communities. This photograph was taken from near the Grandin warehouse in Moorhead. (CCHS.)

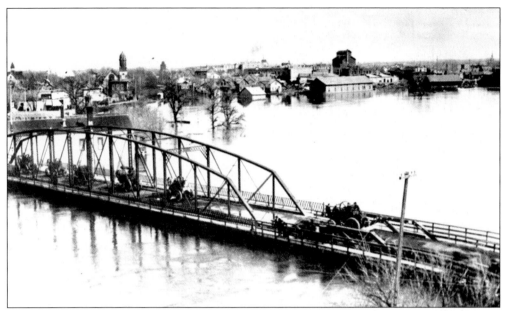

The 1897 flood was even worse. In this image, steam-powered tractors have been placed on the North Bridge, in hopes that the weight of the tractors would prevent the bridge from being washed out. The bridge survived, although great damage was done to large parts of the river communities. (CCHS.)

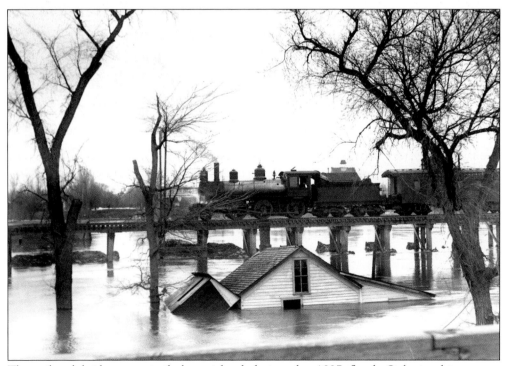

The railroad bridge was similarly weighted during the 1897 flood. Only in this case, a locomotive and loaded rail cars were used to secure the wooden trestles against the force of the river. (NMHC.)

Mosquitoes attacked in swarms in the Red River Valley. Animals sometimes become so frenzied that they ran themselves to death in attempts to escape. In this 1860 illustration from *Harper's New Monthly*, riders in the valley wear gauze-like coverings over their faces, a practice that became known as "taking the veil." (NMHC.)

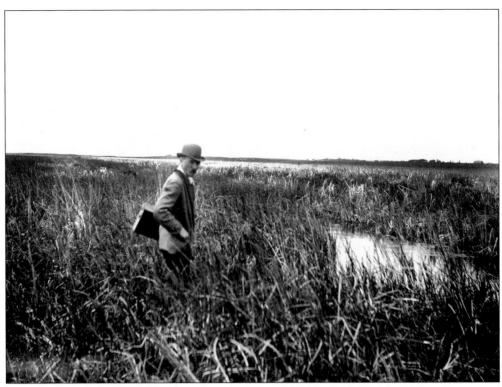

This slough, being traversed by an unnamed photographer in the late 19th century, was typical of thousands of acres in Clay County, low enough to be waterlogged in warm weather, a hindrance to agriculture and a perfect breeding ground for mosquitoes. (CCHS.)

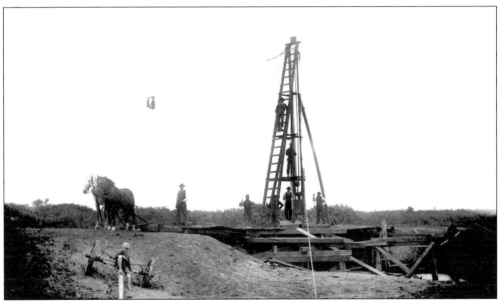

In this image, a construction gang works to bridge a slough or stream. Horses continued to be extremely important as draught animals well into the 1930s. A great deal of land around Moorhead was used to grow fodder for horses instead of food for people. (CCHS.)

In Moorhead, April can be the cruelest month, especially if it brings one final blizzard. Benjamin Mackall is seen here in 1897, removing snow from the entrance of his pharmacy. It was not uncommon for snow to be left on side streets, the routes open only to sleighs. (CCHS.)

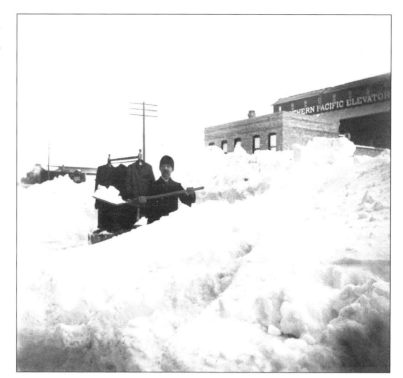

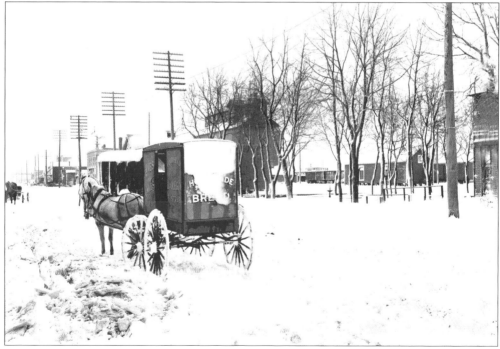

This moment could have been witnessed during any winter over a period of 60 years (the photograph is from 1906). Local bread and milk was delivered by horse-drawn wagons into the 1930s. The drivers were commonly paid only for the days they delivered; most tried to do the job regardless of weather. (CCHS.)

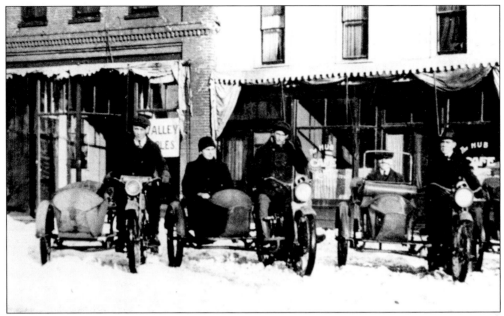

As the motorcycle became more popular, spikes were added to the tires in order to adapt the vehicle to ice and snow. The photographer in this shot from c. 1918 was likely the missing sidecar passenger. (NMHC.)

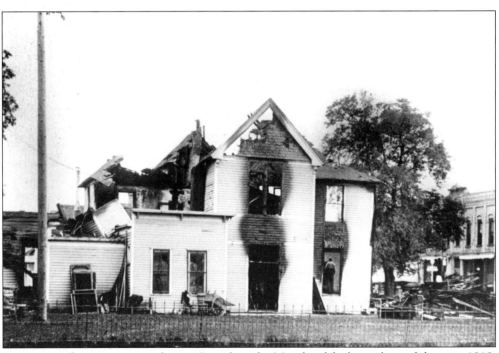

Fire was another ever-present danger. But when the Moorhead firehouse burned down in 1918, some wondered. The Fire Department had requested a new structure for several years, with little response from the city government. Then, while the firemen answered a call from across town, the building suddenly burst into flames. (NMHC.)

Minnesota State Board of Health

SMALLPOX

EXISTS ON THESE PREMISES

Smallpox patients must not leave the house until after the removal of the warning card.

Every person exposed to smallpox, who cannot show evidence of a recent successful vaccination or a recent attack of smallpox, must be vaccinated within three (3) days of first exposure or be isolated for twenty-one (21) days after last exposure.

Only those protected by vaccination are allowed to go into or from this house.

The occupants of this house will be held responsible for the unauthorized removal of this card.

There were serious epidemics of smallpox in Moorhead from 1881 to 1883. Lesser outbreaks occurred in other years, as did epidemics of influenza, diphtheria, and measles. Quarantine signs could be a frequent sight on home entrances. (CCHS.)

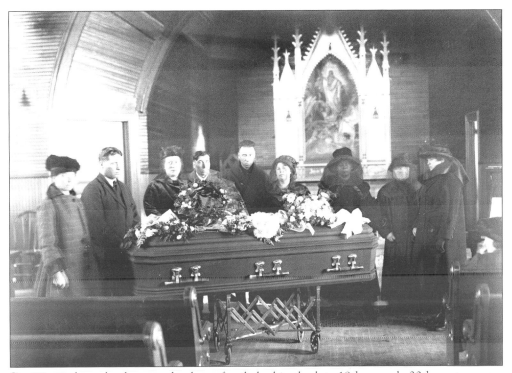

Sometimes the only photographs that a family had in the late 19th or early 20th century were those taken at funerals. Photographers recorded many funeral ceremonies, like this one from c. 1917. (CCHS.)

The first hospital in Moorhead was a privately organized one in 1882, but it didn't last for very long. Northwestern Hospital, established in 1908 by a Swedish Lutheran society, operated until 1920, when a group of Franciscan Sisters purchased and reorganized it as St. Ansgar. This photograph was taken in the early 1930s. (NMHC.)

Olaf Hagen, born in 1872, was raised in Abercrombie in Dakota Territory. After teaching school for a few years, he studied medicine and became a surgeon and a fixture in Moorhead's medical community. Hagen went on to be a nationally known physician, a member of the Board of Regents for the University of Minnesota, and a candidate for the United States Senate in 1940. (NMHC.)

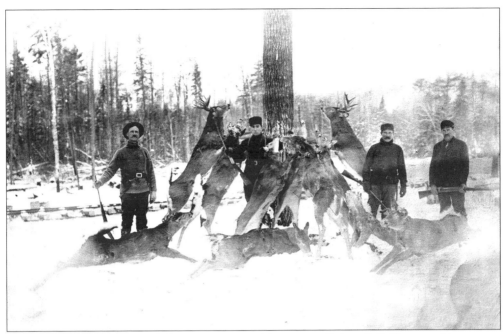

Not all of the environmental damage was caused by nature. Either O.E. Flaten or his partner, Sylvester Wange, made a copy of this photograph. The original print was likely made in the north woods. Minnesota had placed some limits on hunting before Moorhead was settled. (CCHS.)

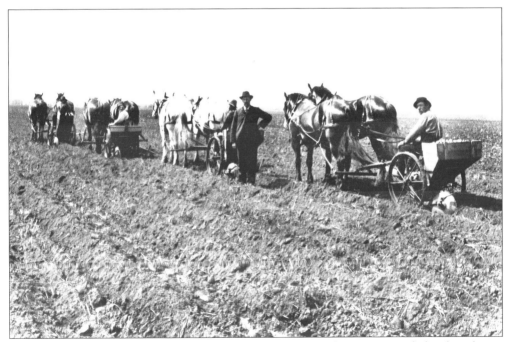

Another man-made problem was soil depletion. Farmers in Clay County and elsewhere began growing large crops of potatoes in the late 1890s. Valley potatoes were of high quality and profitable. But year after year of potatoes or wheat eventually wore out the nutrients in the soil, while chemical fertilizers damaged the land in other ways. (NMHC.)

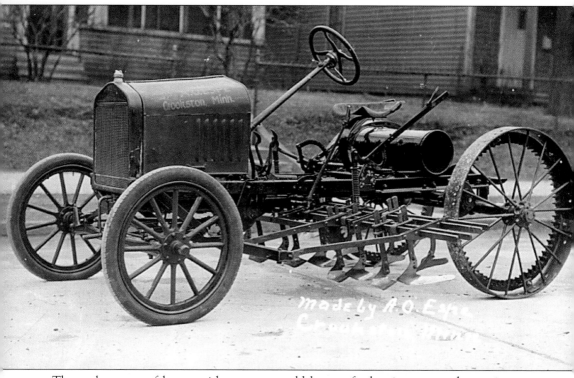

The replacement of horses with tractors would have a further impact on the environment. Many of the earliest tractors in the area were locally made, like this one designed by A.O. Espe of Crookston, north of Moorhead. (NMHC.)

Five
NEW CHALLENGES

Later in the 20th century, writers began looking back on the era from 1890 to 1914 as an almost idyllic time in the nation's history. One historian called them the "Good Years," while Edmund Wilson admitted that he was "enchanted" by memories of "small-town-and-country life" at the turn of the century. Such nostalgia was partly due to the hard challenges that came later—two world wars and the spirit-crushing Great Depression. Anything would look good when compared to those trials.

One cannot deny that the 25 years prior to the beginning of the Great War had their charms. But these years also presented their own challenges. This was as true for Moorhead as anywhere else.

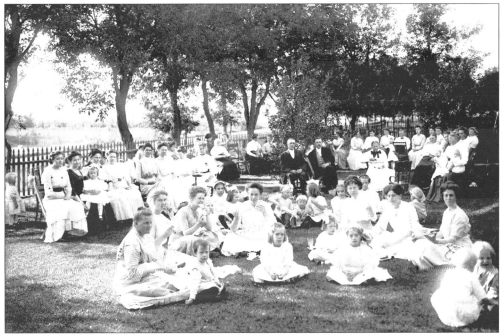

The small town at the turn of the 20th century was seen as the heart of the nation. Writer Henry Canby extolled upon "its streets, still not too congested for pleasant shade, its country roads still quiet to walk upon, its spirit as of a young middle-age when nothing seems to stand in the way of an increasing success." This countryside picnic was held near Moorhead sometime around 1900. (CCHS.)

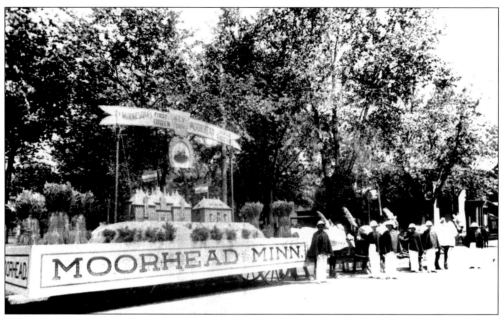

When Minnesota held a festival to celebrate the 65th birthday of James J. Hill in 1893, Moorhead participated with this float. The banner above the reproductions of the buildings "sends greetings" to "Minnesota's First Citizen." Note also the shocks of wheat. (NMHC.)

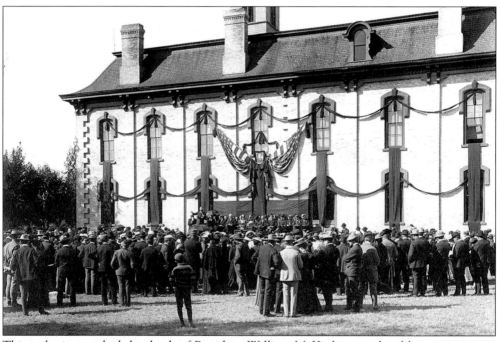

This gathering marked the death of President William McKinley, murdered by an assassin in the fall of 1901. The building is Moorhead High School, built in 1880. Generally, leaders in Moorhead had doubts about American expansion in the Pacific and Caribbean during McKinley's presidency, feeling that it was better for the nation to remain aloof from international complications. (NMHC.)

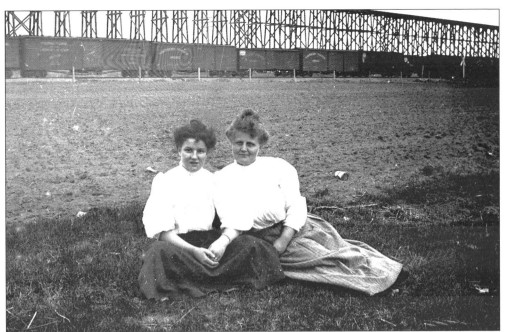

The regional economy continued to grow. Because the valley rested at the bottom of a glacial lakebed, trains had to negotiate a very steep grade when entering Moorhead. In 1906, the Northern Pacific constructed a huge earthen embankment to level the grade. Two women pose here in front of wooden timbers that had been pile-driven into the ground; this framework would be covered and filled with earth and gravel to form the seven-mile embankment. Note the rail cars, filled with equipment for the project. (CCHS.)

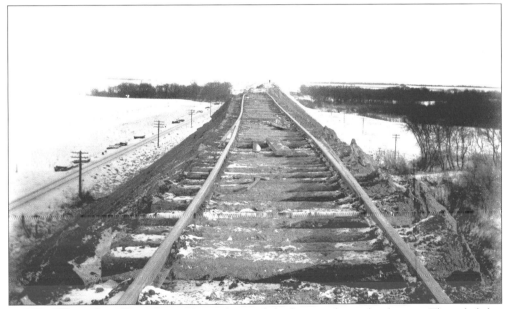

This photograph, taken in 1908, shows the track built atop the embankment. The piled dirt and gravel was very unstable at first and landslides frequently caused sudden depressions that damaged the track. It took over 5 million cubic yards of earth to complete the project. (CCHS.)

Palace Sleeping and Family Tourist Cars

Palace Dinng Cars Meals Served a la carte.

Through service between St. Paul, Minneapolis, Helena, Butte, Spokane, Seattle and Portland Connections at western terminals for Kootnai country, Oregon and California, Alaska, Japan and China. Connections at Twin Cities for all points east and south. Single and round trip tickets to all points and baggage checked to destination.

TIME SCHEDULE.

Trains arrive and depart from Moorhead as follows:

GOING EAST.

No. 2—Via Fergus Falls................11.47 a.m.
No. 4—Limited, via Fergus Falls Division (arriving St.Paul p. m.... 8.20 a.m
No. 1 —Breckenridge division, departsp.m

GOING WEST.

No. 1—To Grand Forks, departs at........ 6.25 p.m.
No. 3—Limited to Coast leaves St. Paul 1.00 p. m., arriving Moorhead........ .2.40 p.m
No. 9—To Winnipeg departs at... a m

MOORHEAD NORTHERN

Going North, leaves......................a.m
Going South, arrives.p.m
Trains run over this line Mondays Wednesdays and Fridays.

For information, tickets, routes, sleeping car berths etc., address

O. THORSON, Agent
Moorhead, Minn.

This news clipping from 1897 lists the daily passenger train schedule for the Great Northern Railway. Another six passenger trains of the Northern Pacific went through Moorhead each day, and there were numerous freight trains as well. (CCHS.)

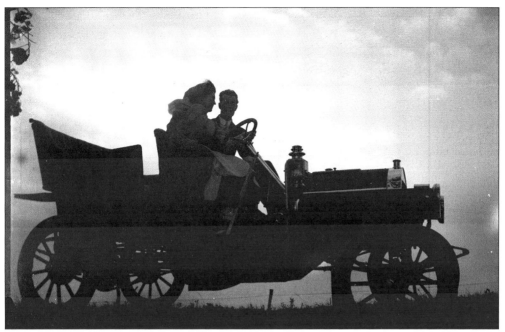

As seen in this photograph taken one evening in Moorhead, trains, horses, and buggies had a new rival. The price of wheat, and the sale of automobiles, rose dramatically in the region after war began in Europe in 1914. (CCHS.)

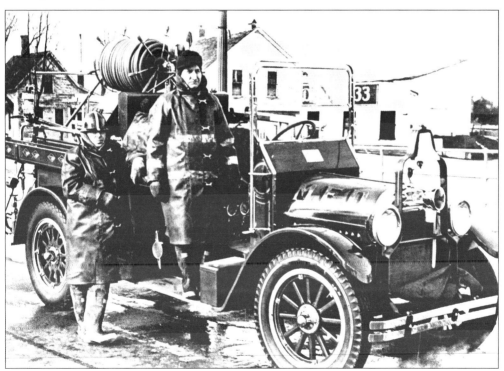

The Moorhead Fire Department purchased this vehicle in 1916, retiring the remainder of its horse-drawn equipment over the next few years. (NMHC.)

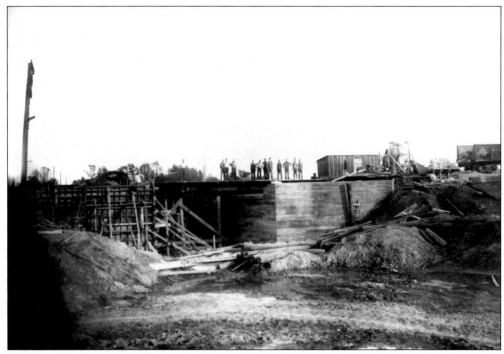

The automobile stimulated major changes in the rural countryside. Workers in this photograph taken c. 1908 are completing a railroad overpass as part of the construction of a state highway. The overpass still stands near Hawley, about 20 miles east of Moorhead. (CCHS.)

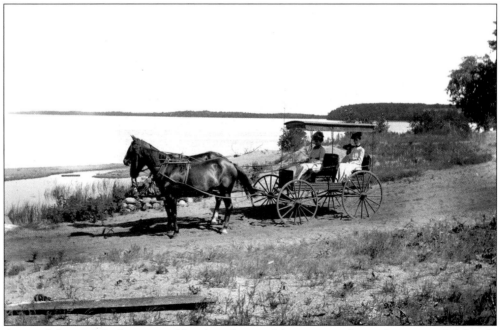

Automobiles and highways swiftly altered peaceful scenes such as this pastoral lakeside moment. The lakes of Minnesota were already attractive to vacationers and tourists, but after World War I, lakeside homes were built in ever-increasing numbers. (CCHS.)

In Moorhead, the growing city population demanded urban improvements. Albert Hopeman became Moorhead's first city engineer in the early 1900s. One of his earliest city projects was the construction of the city's first sewer system. He later went into business as a private contractor. (Photo courtesy of Mrs. Roland Dille.)

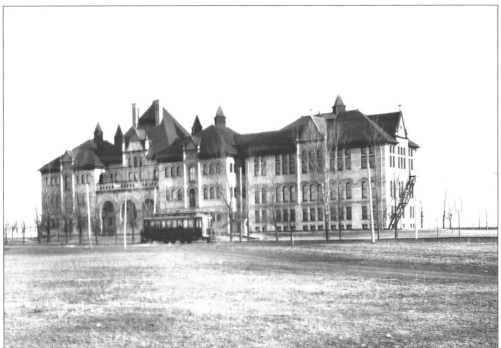

As the town grew, transportation was modernized. A street railway was built in 1902, running from Fargo to Moorhead and out to the Teachers College (above), where it reversed its route. The line was abandoned in 1937, when bus service took its place. (NMHC.)

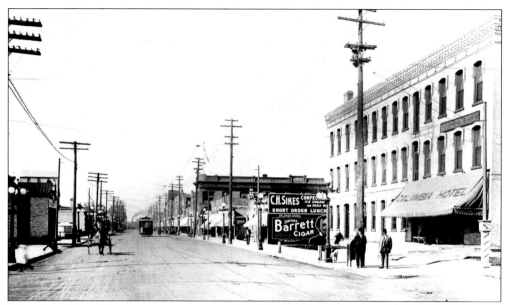

Here the street railway is in operation on Moorhead's Front Street in 1905. Note the horse and buggy in the left foreground and the advertising on the right. In 1942, the Moorhead city government tore out the rails of the defunct line and sold the scrap for use in war production. (NMHC.)

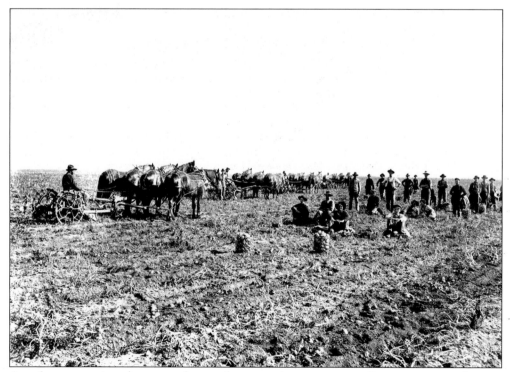

Area farmers continued to grow wheat and potatoes in vast amounts. But as soon as production rose elsewhere, potatoes and wheat glutted the market and lowered prices. Farmers' financial troubles threatened the economy of the whole valley. (NMHC.)

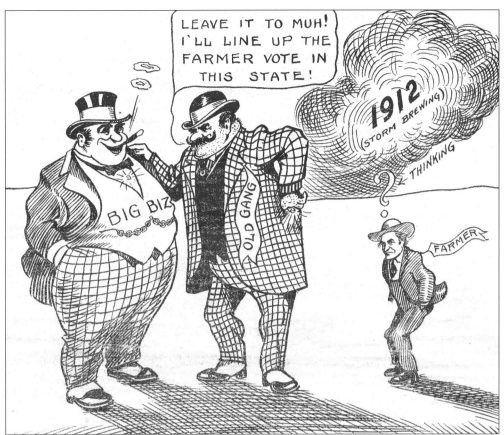

Minnesota and North Dakota turned to protest politics. This cartoon, urging the farmers to wise up and organize, appeared in the *Non-Partisan Leader*, a farmer's weekly newspaper published in Fargo. The non-partisan movement advocated government controls over banks, railroads, grain prices, and other reforms. Within 10 years, non-partisan politics came to dominate government in North Dakota. In Minnesota, the movement helped to give birth to the Farmer-Labor Party, which grew in popularity and influence. By the late 1920s, most residents in Clay County supported the Farmer-Labor Party. Many businessmen in Moorhead, however, were still inclined to be Republicans. (NMHC, from *Non-Partisan Leader*, October 7, 1915.)

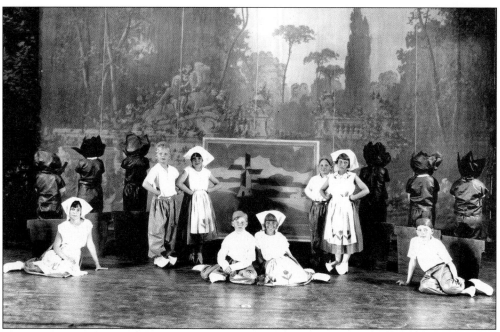

Cultural pageants like this "salute to the world" by Moorhead children in 1912 belied Americans' wishes for a foreign policy of neutrality. When war broke out in Europe in 1914, most in Moorhead wanted to remain strictly uninvolved. But the nation's economy was too closely tied to world markets for isolationism to succeed. (NMHC.)

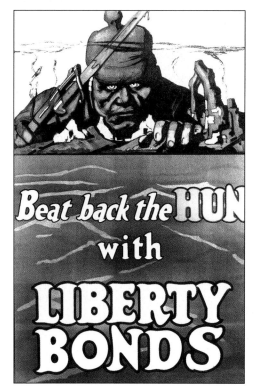

A great many people living in Moorhead, and the Red River Valley, were of German-American heritage. But once the United States entered the war against Germany in 1917, any citizen who expressed sympathy for the "Hun" did so at personal risk. There were several recorded instances in and around Moorhead in which persons who flew a German flag or refused to buy war bonds were threatened with injury. (NMHC image from private collection.)

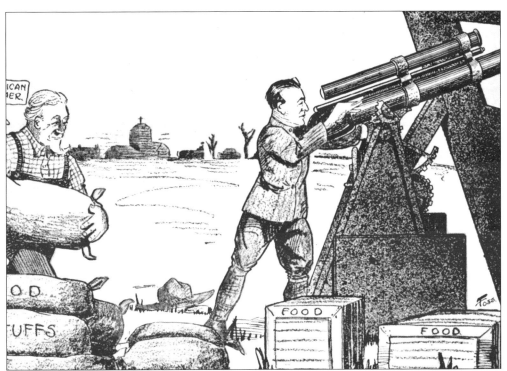

The war restored prosperity to valley farmers. This cartoon from a Fargo newspaper underscores how much the rest of the world depended on American grain during the war. Farmers in Clay County and elsewhere expanded their acreage for wheat and, for a time, reaped good prices for their crops. (NMHC, from *Non-Partisan Leader*, March 4, 1918.)

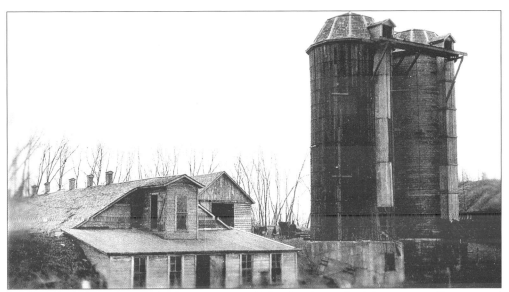

Donald Grant's father owned a farm just east of Moorhead, on which he grew small grains and potatoes. As the price of wheat soared during the war, the Grants planted wheat on nearly all their land. But when victory was won in 1918, "our elevator was full of wheat, and we lost about $10,000 right off when the price of wheat plummeted." (NMHC.)

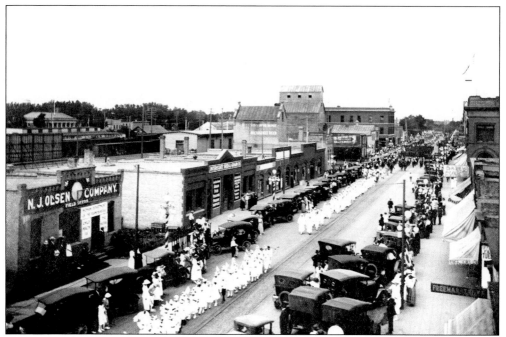

A large number of young men and women from Moorhead served in the Great War. Women from the Nursing Corps, seen above, joined the county's returning soldiers in a combination victory parade and bond rally held in Moorhead late in 1918. (CCHS.)

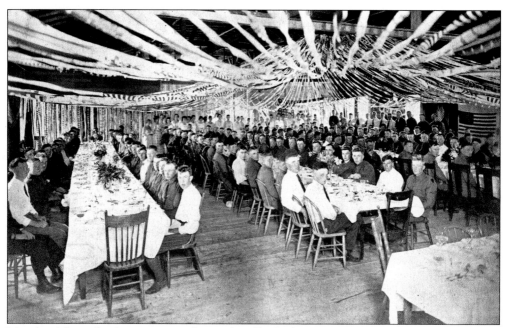

Moorhead hosted a homecoming dinner for all of Clay County's Great War veterans. But underneath the atmosphere of good cheer, there were the first signs of an agricultural depression that would spell hard times for the whole region. (Photograph from *Clay County in the World War*, 1919, copy at CCHS.)

Six
Hard Times

Americans typically remember the Great Depression as a financial and employment crisis that began with the collapse of the stock market in October of 1929. But to many of those who lived in rural America, hard times began well before 1929. The rapid decline in the prices of grain, cotton, and other agricultural commodities after 1920 made the experience of many "country folk" an ongoing crisis that continued through the 1920s and on into the next decade.

As the farmers suffered, so too did those living in the neighboring towns. The population of Moorhead grew from about 5,000 in 1920 to a little over 9,000 by 1935. All of these men, women, and children—even those who were prosperous—would retain an indelible memory of the hard times that characterized these years.

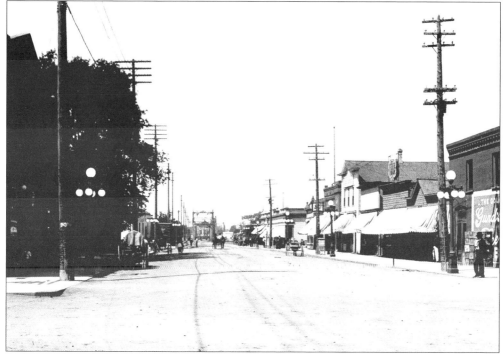

As the farming crisis deepened in the valley, Moorhead merchants worried that their businesses would suffer. The business district, including those shops in this section of town, soon had fewer customers on Saturdays, when the rural population normally came to shop. (CCHS.)

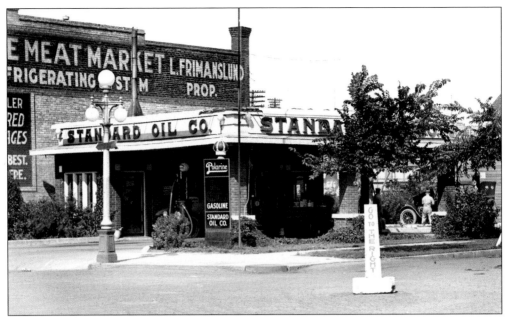

The Standard Oil Company station stood at the corner of Main and 4th Street for many years. (This photograph was taken in 1923.) During the hard times, many farmers continued to use horses and buggies because they could not afford to buy gasoline. (CCHS.)

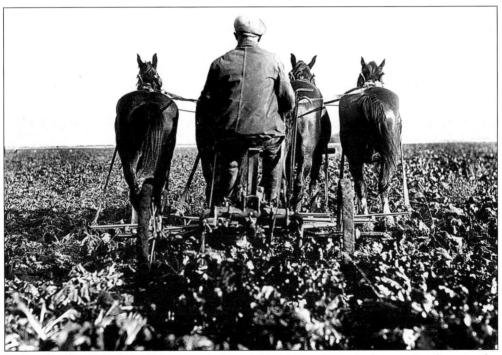

In this photograph, a farmer uses a horse-drawn cultivator on his sugar beets. Most farmers who received sugar beet contracts in the early years grew from 25 to 40 acres. Sugar beets required much hand labor, so from the earliest years, farmers in the valley relied largely on Mexican-American field workers from Texas, recruited by the company. (NMHC.)

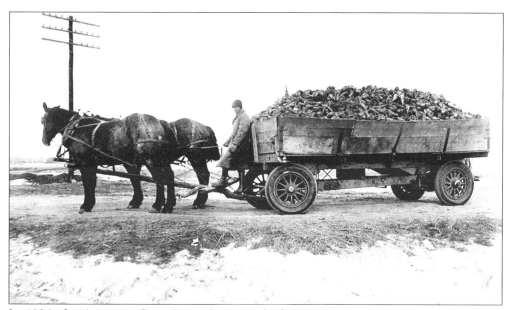

In 1926, the American Beet Sugar Company built a processing factory in the valley and signed local farmers to growing contracts. Sugar prices were high enough so that growers who delivered them to the company, as in the image above, could usually make a profit. But in the drought and dust years of the mid-1930s, even this crop did little to help struggling farmers. (NMHC.)

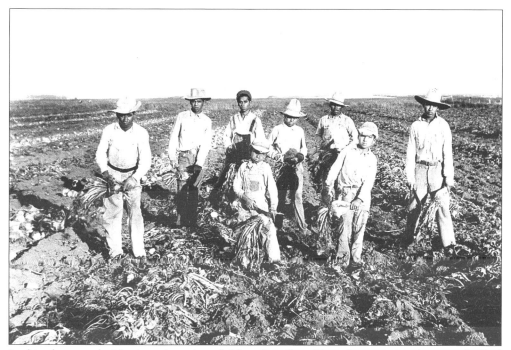

In this photograph, Mexican-American field workers from Texas harvest sugar beets in the Red River Valley, c. 1930. Such workers typically lived in very small houses near the farm where they worked and were seldom seen in Moorhead and the other towns. (NMHC.)

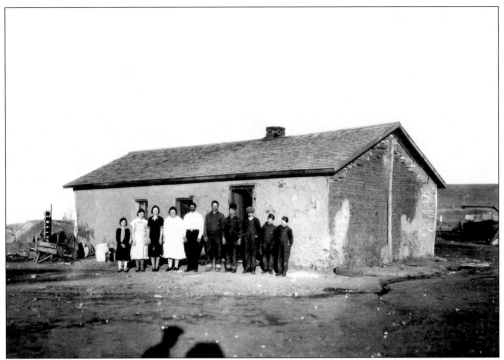

Some North Dakota farmers also grew sugar beets, but most continued to grow small grains. As this late 1920s–early 1930s photograph of a Dakota farm family standing outside their sod house suggests, many were living in very difficult circumstances. (NDIRS, 2023.52.8.)

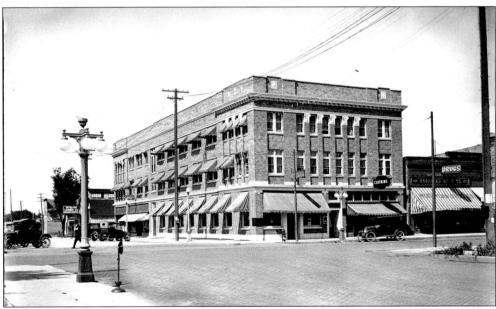

As the financial difficulties grew, local banks, including the First State Bank pictured above, began to fail. By the end of the 1920s, only one bank remained open in Moorhead. It had been established and stabilized by a local grain merchant with assistance from the regional branch of the Federal Reserve. (CCHS.)

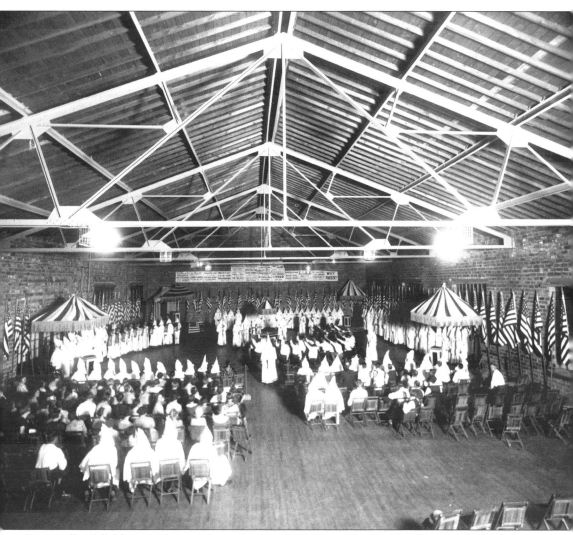

Some valley folk blamed "sinister" forces for their hard times. The Ku Klux Klan briefly grew in the valley region the 1920s. This photograph records a meeting of regional KKK membership at the Moorhead armory, c. 1925. For the most part, the Klan in the area confined its efforts to attacking Catholic influence in local politics and schools. Membership in the KKK was hardly a well-kept secret: a woman remembered in the 1980s that, when she was a little girl, her mother had reminded her not to call out and wave to her uncle in the ranks of a Klan parade. (CCHS.)

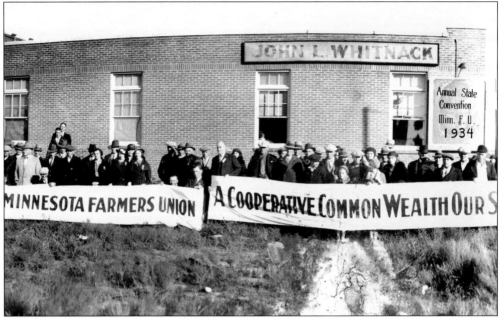

Hard times gave birth to a new organization, the Farmer-Labor Party. It swept into power in Minnesota with major election victories from 1926 to 1930, and initiated a number of measures to help farmers and labor unions. At a state convention held in Moorhead in 1934, the Minnesota Farmers Union showed its support for the Farmer-Labor Party, proclaiming "A Cooperative Commonwealth Our Shining Goal." (NMHC.)

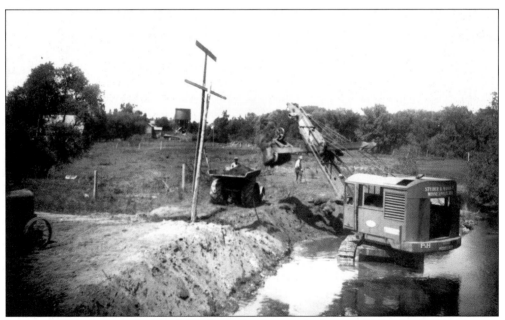

In this c. 1930 photograph, Trunk Highway 2 is being rebuilt east of Moorhead. The Farmer-Labor-dominated state government invested funds in this and other public projects. The Farmer-Labor Party was popular with Clay County farmers and those out of work, but unpopular with many businessmen in Moorhead. (CCHS.)

Hundreds had lost their farms in the depression, mostly because the farmers could not afford to pay property taxes. In response, farmers formed the Farm Holiday Association, which lobbied state governments to declare moratoriums on property tax payments. FHA members also gathered to protest foreclosure auctions. (Photograph courtesy of University of North Dakota.)

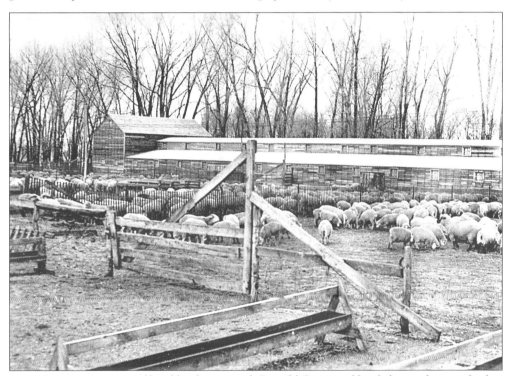

In 1930, representatives of local banks met with Donald Grant and his father to discuss whether or not to foreclose on their indebted farm operation. They decided "to let us go on as there was no one to sell the farm to." By raising sheep and selling the wool, the Grants slowly paid off the debts while waiting for a return to better times. (NMHC.)

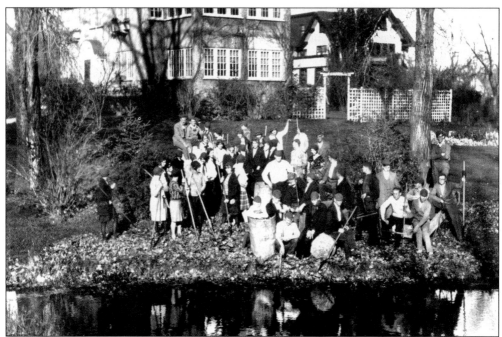

In this photograph, Concordia College students clean up leaves on the campus in the mid-1930s. Many students were able to attend college only with the assistance of the National Youth Administration (NYA), a New Deal program that granted small amounts of money to students in return for work. (Photograph courtesy of Concordia College Archives.)

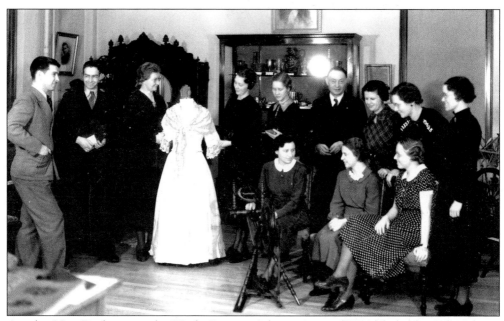

Another New Deal agency, the Works Progress Administration (WPA) helped pay the salaries for the employees of the Clay County Historical Society in Moorhead. Many of the men and women in this mid-1930s photograph were college students who worked at the museum with WPA assistance. (CCHS.)

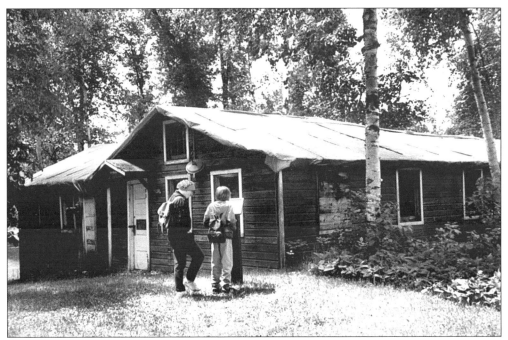

Tourists visit the site of Camp Rabideau in north-central Minnesota in 1996. This was one of several Civilian Conservation Corps (CCC) camps in Minnesota in the 1930s. The CCC was one of the most popular New Deal plans for combating unemployment. A number of young men in Moorhead joined the CCC during the Depression years, some of them working at this camp. (NMHC.)

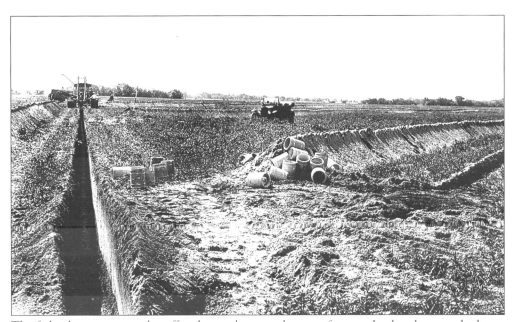

The federal government also offered some low-cost loans to farmers. In the photograph above, taken c. 1938, workers at the Grant farm east of Moorhead are installing drainage tile, paid for with a federal agriculture loan. (NMHC.)

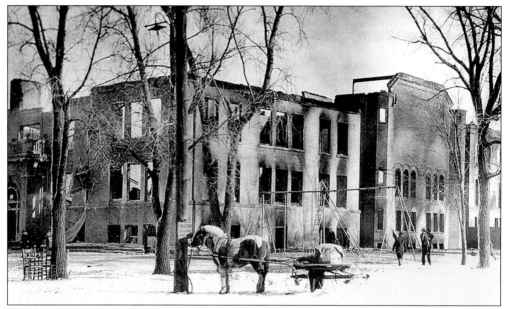

Moorhead State Teachers College suffered a tremendous loss in February of 1930 when the original college building was destroyed by a fire that began when frayed insulation on a steam pipe ignited. Students had to complete the academic year with classes in the hallways of other buildings. Two new buildings, built with funds provided by the state government, opened in 1933. (NMHC.)

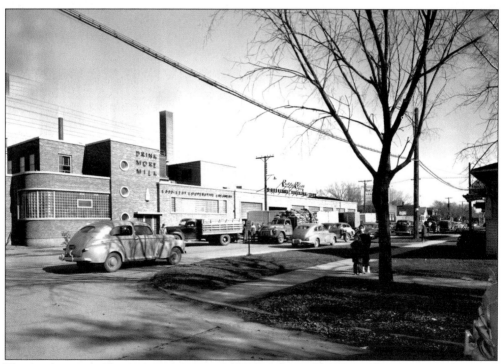

The local economy began to improve in 1938. Employers like Cass-Clay Creamery (pictured above), increased their hiring as the financial picture improved. Cass-Clay was the largest employer in Moorhead throughout the 1930s and 1940s. (NMHC.)

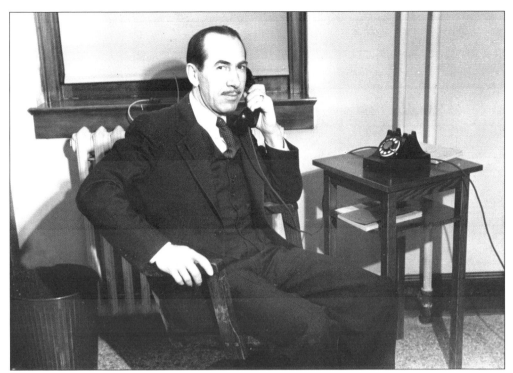

Byron Murray wrote most of the editorials for the *Moorhead Daily News* throughout the 1930s. Although he took a relatively isolationist stance in the newspaper regarding American foreign policy, privately he told his family that he doubted the United States could remain neutral in the face of rising German and Japanese aggression. (NMHC.)

In December of 1939, Moorhead was enjoying one of the warmest Christmas seasons in memory. Temperatures were in the 60s; people could pose for pictures next to the community Christmas tree in their shirtsleeves. But war was already raging in Europe and Asia. (NMHC.)

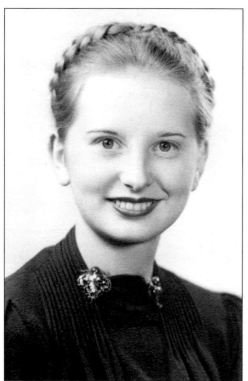

Carol Raff, a student at the Teachers College, was the editor of the college newspaper in the fall of 1939. She spent the next year urging other students to support American neutrality in the war in Europe, writing "Our slogan must be: We will not fight in Europe." Ironically, when war did come, she married a man who made a career in the post-war Air Force. (NMHC.)

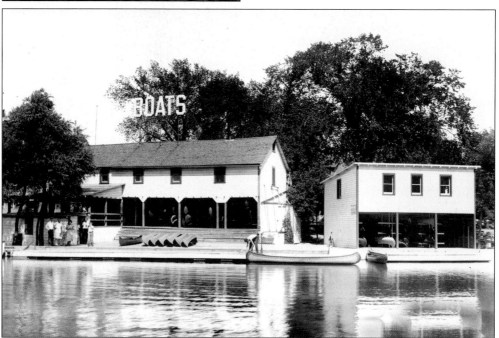

Frank Dommer's Boathouse in Moorhead was a favorite 1930s hangout for young men and women, a place where they could swim in the Red River or rent a canoe and cruise leisurely along. How many local men later remembered those happy days at home, while waiting to land on a beach in Europe or the Pacific? (CCHS.)

Seven
WAR AND NEW PROSPERITY

In modern memory, World War II seems to be remembered as the "best war ever." That was not how Americans saw it at the time, however. The people of Moorhead, like most everyone else in the nation, reacted to the news of Pearl Harbor with shock and a sense of resignation that they would have to fight another brutal struggle overseas. While, again like most Americans, those from Moorhead who went into the services did their duty willingly, they also wanted to win the struggle quickly, come home, and get on with their lives.

Meanwhile, on the Moorhead home front, the residents also did their bit to win the war. This usually meant making do with what they had, dealing with shortages and rationing, working extra hours, and worrying endlessly about their loved ones in harm's way. There was also a nagging fear that this struggle too would be followed by a postwar depression. On that score, at least, the victors were in for a pleasant surprise.

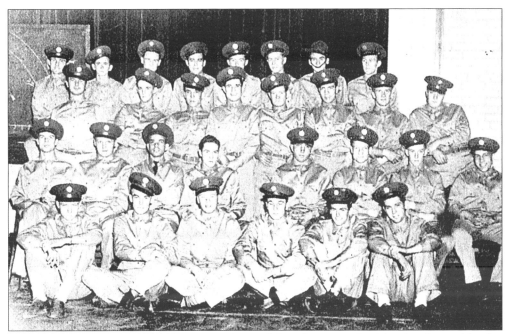

Members of Company F of the Minnesota National Guard, stationed in Moorhead, posed for this photograph in late 1940 or early 1941. Many of these men were college students who joined the Guard to earn a little extra money. Company F was called into active Army duty before Pearl Harbor, and saw action in the Pacific. Two men in this photo were killed in the war: Clarence Johnson (back row, third from left) and Cyril Karsnia (front row, fourth from left). (NMHC.)

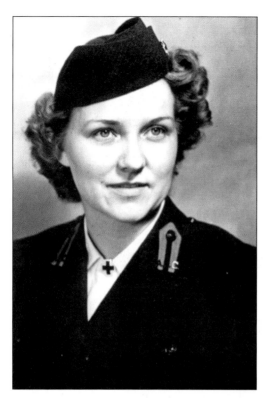

Large numbers of women enlisted in either the military or in military-related services during the war. Doris Solem, a graduate of Moorhead State Teachers College in 1937, taught in rural schools until 1942, then joined the American Red Cross and went to the Pacific as a nurse in Australia. After the war, she returned to teaching. (NMHC.)

Don Tescher, another graduate of the Teachers college, was a conscientious objector who performed alternative service under the Federal Civilian Public Service program. After working on erosion and forestry projects in Indiana and Michigan, he was an aide at a veteran's hospital in New Jersey. After the war, Tescher became a college teacher. (NMHC.)

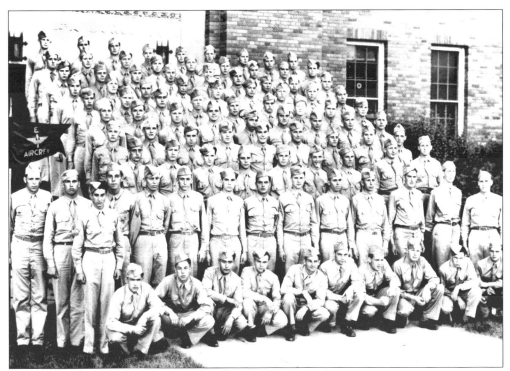

Moorhead State Teachers College lost most of its male students to military service, but compensated by becoming a training center for the Army Air Force's "Cadet Training" program. Many of the cadets in the various flights, like the one above, enjoyed their three-month stay in Moorhead because they were treated well by the local residents. A few returned to live in Moorhead after the war. (NMHC.)

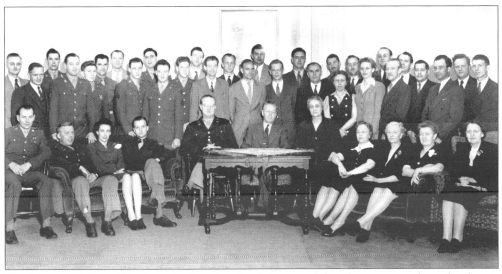

The Moorhead State Teachers College faculty did most of the classroom teaching for the air cadets, while the program's military officers concentrated on administration and discipline. College rules had prohibited smoking on the campus, but the rule was rarely enforced during the two years the cadets were at MSTC. (NMHC.)

The war had an enormous impact on population migration. Carroll Eian, a small town native, graduated from Concordia College in 1942 and took a job in Ohio to do research for military aircraft production. After the war, he settled in urban Ohio with a job in the commercial aircraft industry. (Photograph courtesy of Concordia College Archives.)

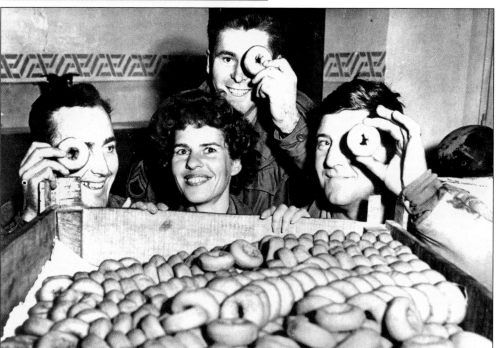

The regional Red Cross, headquartered in Moorhead, tried to keep track of every local resident who served in the American military. This photograph of Private Frank Harley (far left) was taken at a Red Cross service center in Italy in 1943. (NMHC.)

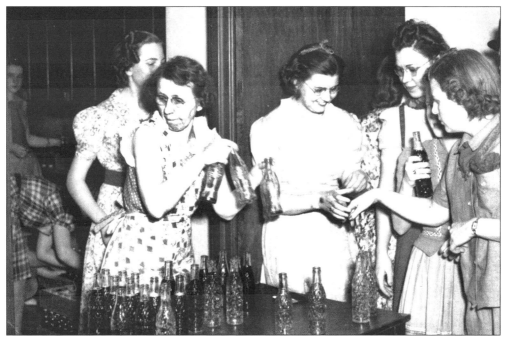

Moorhead maintained an informal "USO" for servicemen and servicewomen at the local American Legion Hall. Flora Frick (left, holding the Coke bottles) was most active in the war effort, continually organizing war-related activities and urging local college and high school students to write to soldiers and sailors overseas. (NMHC.)

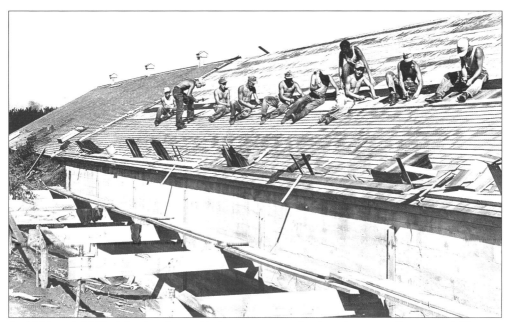

In 1944 and 1945, Moorhead provided a warehouse for housing a small group of German prisoners of war. The POWs were transferred from a larger camp in Iowa in order to help local farmers tend and harvest their crops. After the war, some of the former POWs contacted some of the farmers to ask for jobs in America. (NMHC.)

St. Joseph's Church in Moorhead operated an innovative day care center during the war by watching the children of migrant workers who came from Texas to help with the harvests. Students from the local colleges "did their part" by coming to the church to read stories to the boys and girls. (NMHC.)

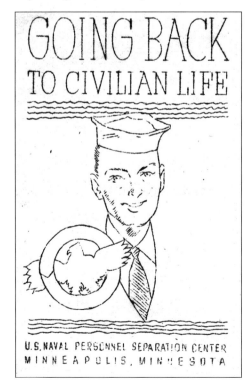

The home front press discussed at length how the nation should provide for its veterans after the war was won. The *Country Press*, one of the local Moorhead newspapers, argued that for "what the soldiers endured," the nation had to make a better world in which all could "enjoy the blessings of American freedom and opportunity." (NMHC.)

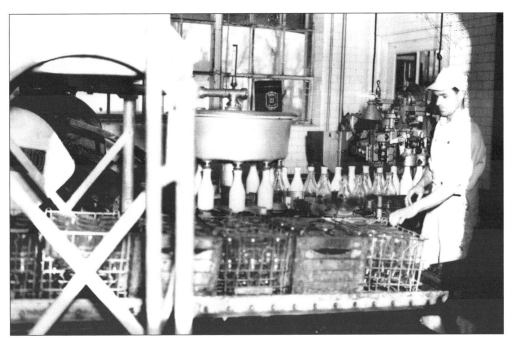

The Fairmont Creamery plant in Moorhead received a contract from the Army to produce powdered eggs for the troops. The plant hired dozens of women to work eight hours, in three shifts, breaking eggs for the ovens. The paycheck they received was often the most money they had ever earned. (CCHS.)

Lend-lease food programs for America's allies meant that shoppers in Moorhead had to endure rationing and shortages in meat, sugar, canned goods, and many other items. From 1943 on, there were rumors of local black market arrangements for meat, scarce vegetables, and gasoline. (CCHS.)

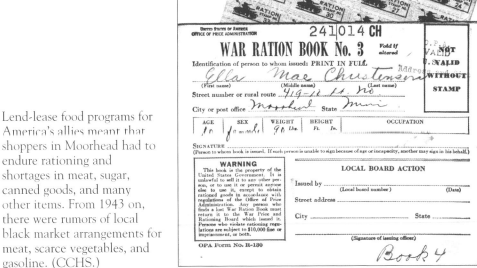

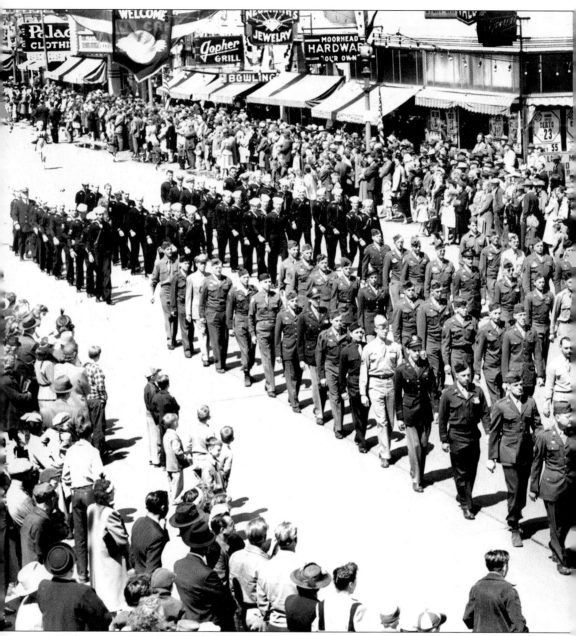

In the spring of 1947, Moorhead hosted a "welcome home" celebration for all the returning veterans of the war. The parade of the former servicemen, many in uniform, was considered the highlight of the festivities. Most of the returning G.I.s wanted to put their war experiences behind them and get on with their lives; a number used the G.I. Bill of Rights to enroll in local colleges and technical programs. More marriages were recorded in Clay County in 1946 and

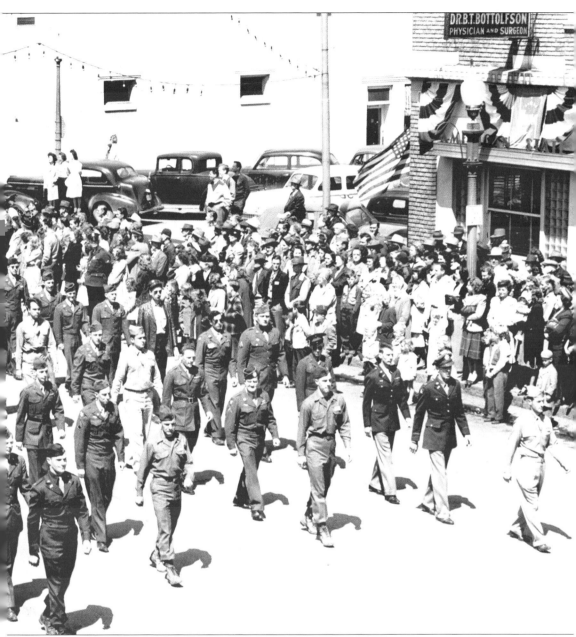

1947 than in any previous two year period, and the new young couples needed housing, furniture, and all the things that Americans expected for new homes. They chafed at the delays that occurred while American industry converted to peacetime production. None of them realized at the time that they were part of the beginning of an unprecedented era of national, and local, prosperity. (NMHC.)

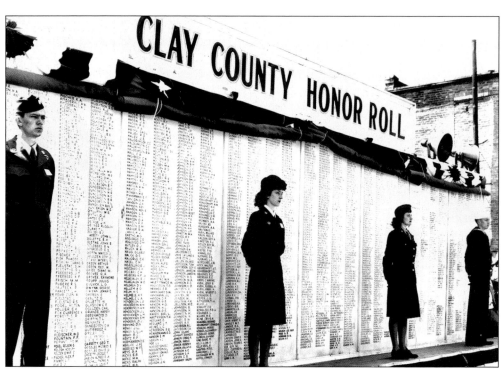

An Honor Roll recording the names of those Clay County residents who served in the war was constructed as a permanent monument. But like so many other things, it was lost when the city was rebuilt in the 1960s. (NMHC.)

An economic boom followed victory in World War II. In Moorhead and surrounding communities, returning veterans demanded new homes; entirely new neighborhoods were built in response. (NDIRS, 2070.250.4.)

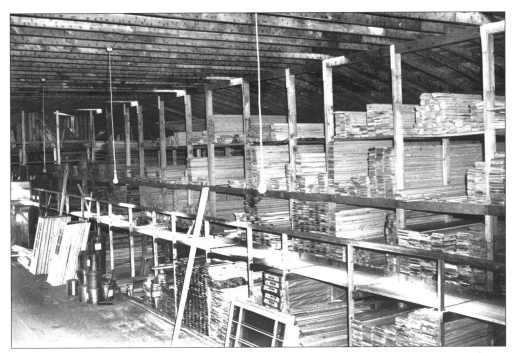

During the war years, lumber had been scarce and non-war-related construction almost nonexistent. This 1949 photograph of the interior of the Stenerson Lumber warehouse in Moorhead gives some idea of the demands of the postwar housing boom. (NMHC.)

Those new homes were quickly filled. By the late 1940s there were so many kids living in a prefabricated housing complex built for ex-servicemen and their wives that locals called it "fertile acres." (Photograph courtesy of Virginia Kolba.)

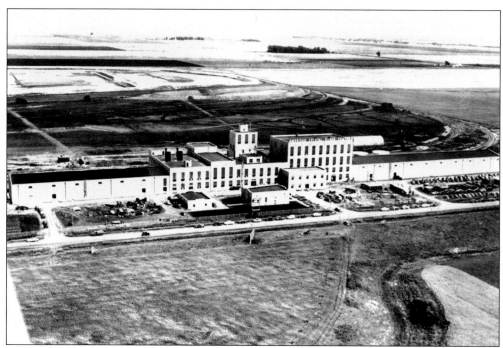

In September of 1948, the American Crystal Sugar Company opened its Moorhead processing plant. With 300 employees and an annual payroll of $500,000, the new beet sugar plant was an enormous boost to the local and regional economy. (NMHC.)

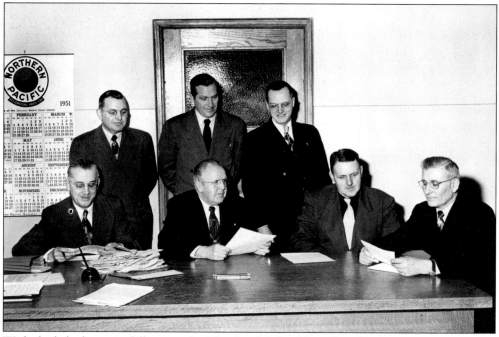

With the baby boom in full swing, the Moorhead School Board made plans for expanding the existing schools and building new ones. Here, the board meets in 1951 to consider proposals for a new elementary school. (NMHC.)

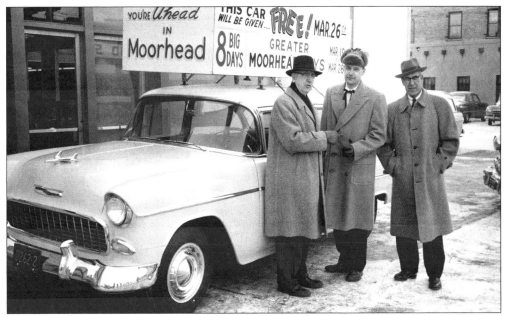

In the 1950s, American car manufacturers could readily sell every vehicle that came off their assembly lines. Here organizers of the Greater Moorhead Days celebration for 1955 hand over the weekend's grand prize, a new Chevrolet. (NMHC.)

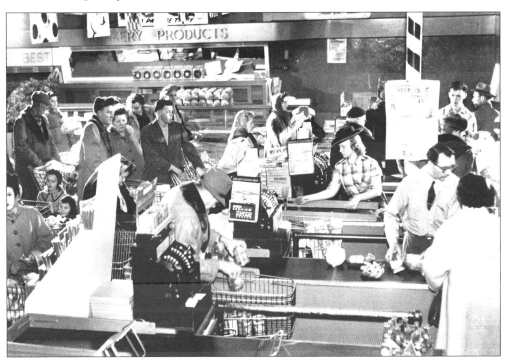

The Red Owl Grocery opened in Moorhead during the Depression, expanded into a new location after the war, and by the 1950s was making it tough for smaller grocers to compete. By then other chain stores were also in operation. While consumers loved the chains, the smaller businessmen feared their size and lower prices. (NMHC.)

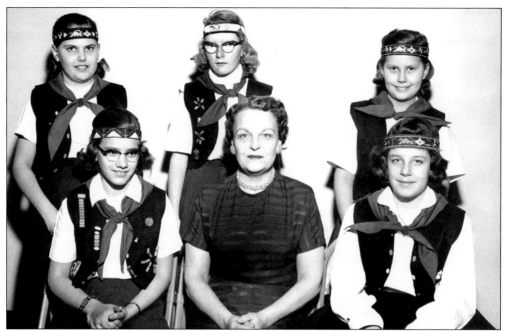

Five members of the Lincoln elementary sixth grade pose with Mrs. Daly, their Campfire Girls leader, in 1958. The next decade would bear witness to momentous changes as the baby boomers began to come of age. (NMHC.)

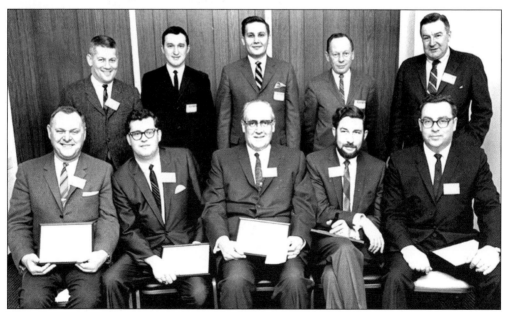

The physical and economic changes in Moorhead and neighboring Fargo had been accompanied throughout the 1950s by an explosion in media. Here, c. 1960, representatives of the three newspapers, four radio stations, and four television stations gather for a group picture. The venerable *Moorhead Daily News*, the city's main newspaper for over 70 years, had ceased publication in 1957. The remaining media would have plenty of change to cover in the coming years. (NMHC.)

Eight
Times Were Changing

Perhaps the greatest era of change for Moorhead came in the 1960s and 1970s. It was during this period that Moorhead's population reached 30,000. City leaders expected the population to continue to grow at "fifteen to twenty percent per decade" for the rest of the century. Several new neighborhoods were built to accommodate this growth and city services were examined in anticipation of the increased demand.

It was also during this period that opportunities to rebuild the city with federal redevelopment funding assistance resulted in a major facelift for the heart of the city. Much of the "old" Moorhead was razed to the ground, particularly in the downtown business district, and a new downtown was built to replace it. By the end of the 1970s, Moorhead looked—and felt—very different from what it had been 20 years earlier.

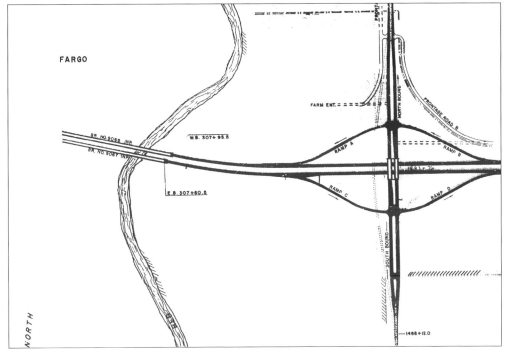

This portion of a planning map for U.S. Interstate 94 shows the location of the new highway bridge across the river and the Moorhead exit ramp. Construction of the ramp began a few years after this drawing was completed in 1954. Moorhead began rapidly expanding east and south toward the new highway. (Drawing courtesy of Tom Swenson, Minnesota Department of Transportation.)

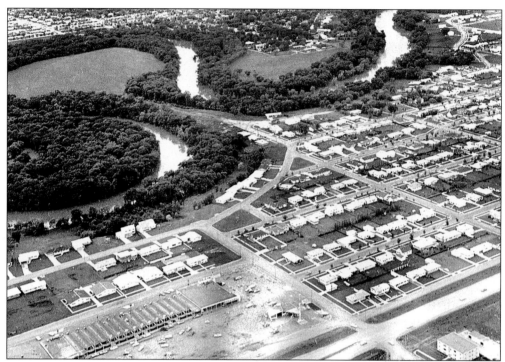

The first shopping center in Moorhead is visible in the lower left of this 1960s aerial view. Most of the houses laid out near the Brookdale Shopping Center were built during the 1950s and 1960s. (NMHC.)

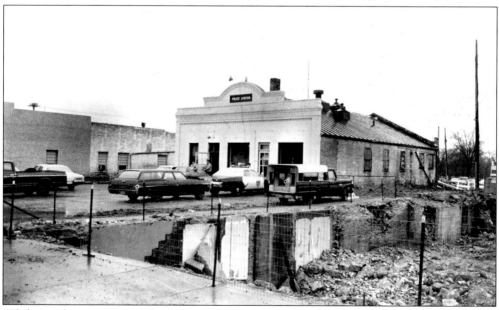

While new homes went up, the business district of Moorhead declined. This photograph of the city police station, taken c. 1967, shows the obvious decay of the building. By this time, Moorhead city government and business leaders were already organizing efforts to redevelop the heart of the city. (NMHC.)

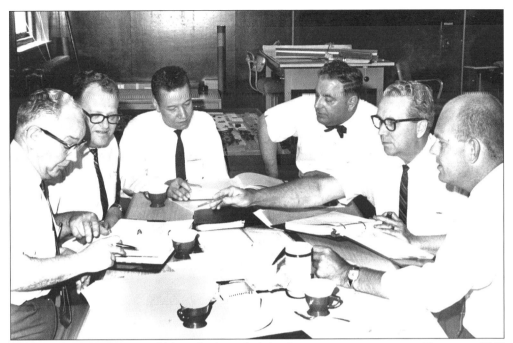

Moorhead's downtown would be rebuilt with federal government assistance. Here at a 1966 meeting of the Moorhead Housing and Redevelopment Authority, local and federal representatives firm up plans for rebuilding the downtown area. (NMHC.)

These older buildings on Moorhead's 4th Street had long been used for small businesses and inexpensive apartments. Structures such as these were among the first identified for demolition in the redevelopment project. Some citizens would later mourn the loss of these representatives of historic architecture, but objections were muted at the time they were torn down. (NMHC.)

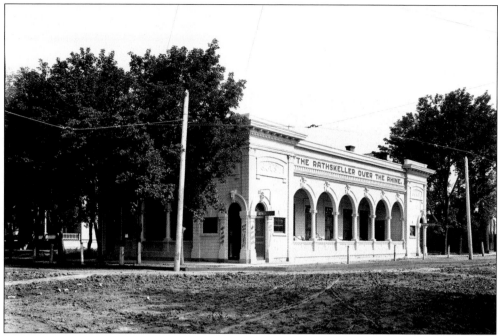

One of the last remnants of the old saloon era in Moorhead, the Rathskeller Over the Rhine, was also earmarked for demolition. When it was torn down in the 1960s, contractors found a cache of old correspondence concerning liquor sales around the valley; these letters were preserved as part of the community's history. (CCHS.)

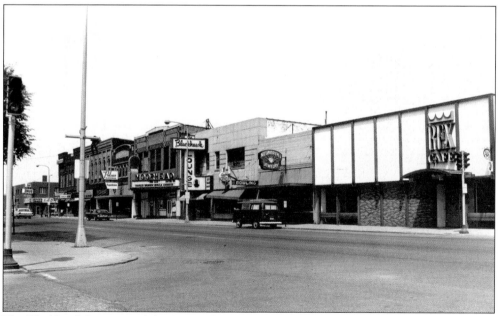

The Blackhawk Lounge and the Rex Café on Center Avenue were popular establishments, but the buildings they were housed in were old, their deteriorating structures sheathed in tile and stucco. The redevelopment plan called for this entire block to be demolished and rebuilt with urban renewal money. (NMHC.)

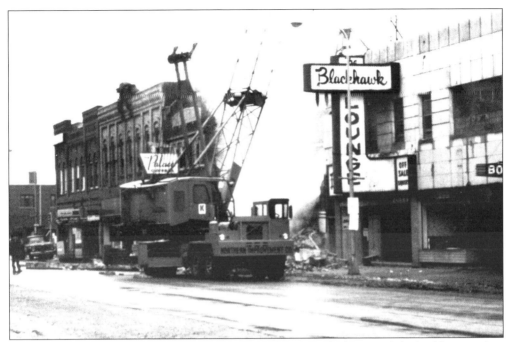

The Moorhead Fire Department made a photographic record of many of the buildings as they were demolished. Here the same section of Center Avenue goes under the wrecking ball in 1973. (CCHS.)

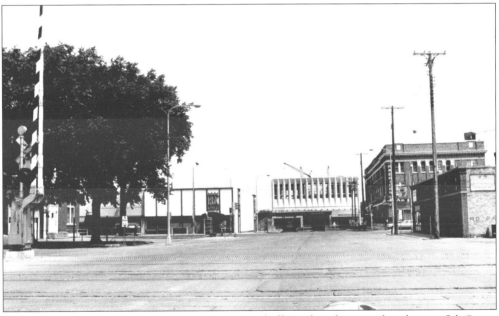

The centerpiece of redevelopment was a new city hall. In this photograph, taken on 5th Street looking north, the second level of the building is being completed. The planners for this structure had determined in 1970 that the city hall "would become the focal point for development by providing public space for an outdoor plaza and an enclosed climatized mall with office space above." (NMHC.)

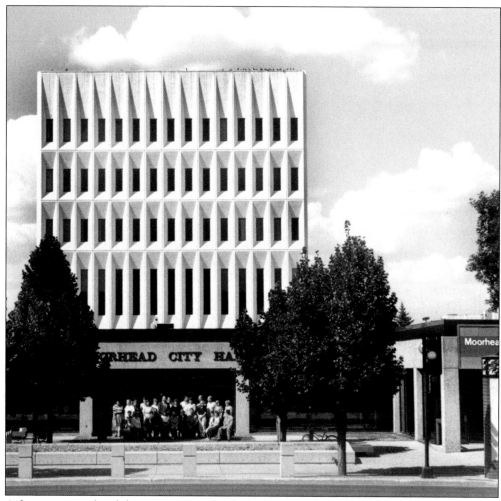

A fountain completed the construction for the new City Hall. The entrance to the government building also served as an entrance to the new Moorhead Center Mall. The mall was an immediate commercial success. But Fargo completed an even larger mall on its south side around the same time, and the two communities began to compete vigorously in offering leases to prospective stores. This brisk commercial competition of the two cities has continued, and has had influence on such issues as local taxes, pay and benefits for employees, and further commercial development. (Photograph courtesy of the Economic Development Office, Moorhead City Government.)

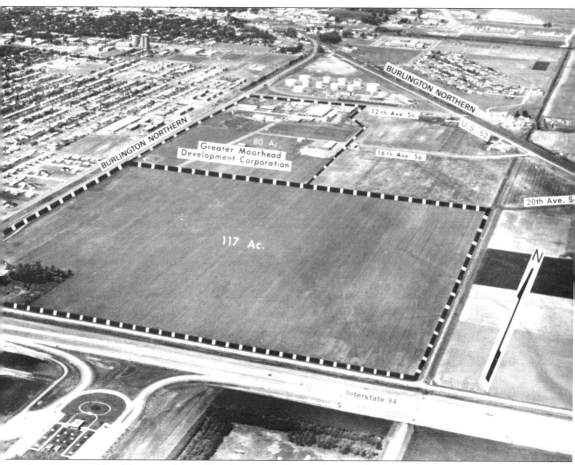

Acquisition of land for an industrial park was another goal set in the 1960s and 1970s. The land selected was at the east end of the city, where access to the new federal highway and the still-important rail lines would be convenient. These developments on the eastern edge of Moorhead ensured that over the next 30 years the city would continue to expand in that direction. By the early 1980s, Moorhead and its most immediate neighbor Dilworth were practically contiguous communities, a situation that made it necessary for the two city governments to engage in some joint planning. (NMHC.)

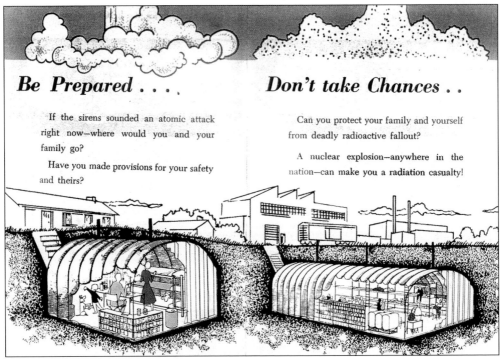

Not all of the construction in Moorhead resulted in new commercial buildings. These plans for a family fallout shelter were part of a brochure prepared by a local contractor in 1962, the year of the Cuban Missile Crisis. A few such shelters were built during the height of the Cold War. (CCHS.)

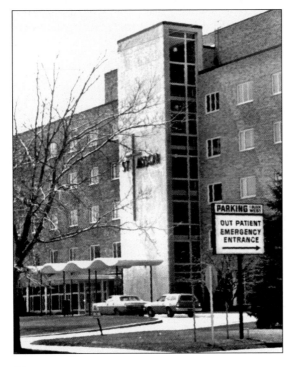

In order to meet new demands, St. Ansgar Hospital was expanded and renovated. The expansion and upgrading of hospitals reflected not only the growth of the population but also the impact of such federal programs as Medicare. (NMHC.)

In 1971, Moorhead celebrated the 50th birthday of its old high school, even though classes had by then moved to a newer building. Posters advertising the reunion featured a drawing not of the existing building on 8th Street, but of the original high school, named after Moorhead pioneer James Sharp, built in 1882 and demolished in 1921. (NMHC.)

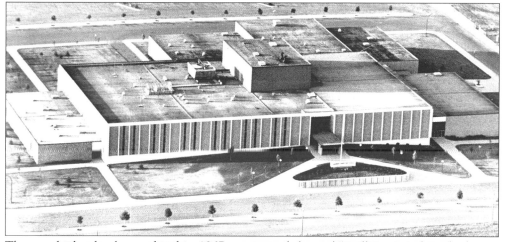

The new high school, completed in 1967 at a cost of almost $5 million, was then the largest building in the city. But older adults in Moorhead were already concerned that the students were no longer as respectful as *their* generation had been. (NMHC.)

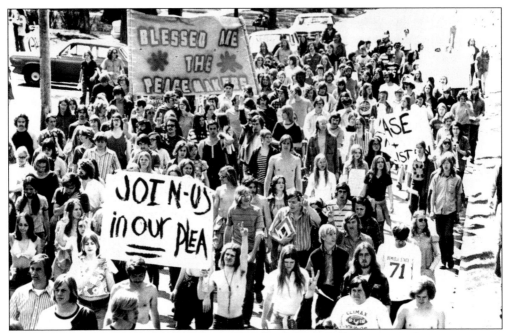

In the later 1960s, students and faculty at Moorhead State College organized a movement to oppose American actions in Vietnam. In 1972, a college photographer captured this moment when MSC students protested the American mining of North Vietnam's principal harbor. The anti-war movement strained town-and-gown relations. (NMHC.)

Moorhead State students invited author Vine Deloria and Native-American activists to speak on campus in January of 1972 as part of an effort to expand the curriculum by adding programs in Native-American Studies, Black Studies, and Women's Studies. Deloria, in a "calm speech advised students to get involved in major party politics on the grassroots level as the only way for them to accomplish any change." (NMHC.)

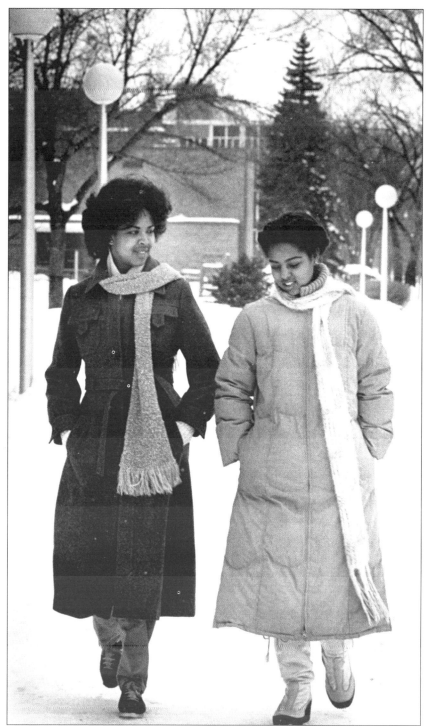

By the 1970s, both Moorhead State University and Concordia College were actively recruiting both American minority students and international students. The students in this photograph came from Ethiopia to take classes in the early 1980s. (NMHC.)

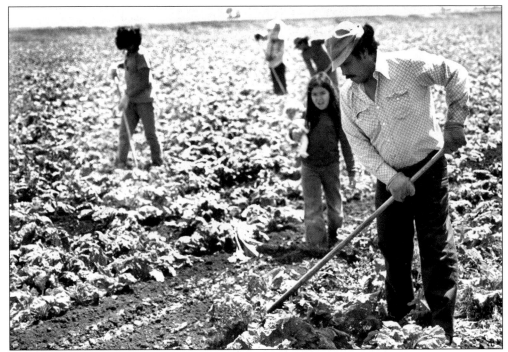

By the 1960s, some Mexican-American families who had worked in the sugar beet fields were choosing to live permanently in Moorhead and elsewhere in the Red River Valley. This trend accelerated as sugar beet farmers relied less on field workers and more on machinery and herbicides for the cultivation of the crop. (NMHC.)

Migrant workers had lived on or near the farms for which they worked. This building above, still standing south of Moorhead, was probably used for migrant housing at one time. But as state and federal regulations changed concerning the facilities for housing, many farmers stopped providing it. Migrant families began renting apartments in Moorhead and elsewhere. (NMHC.)

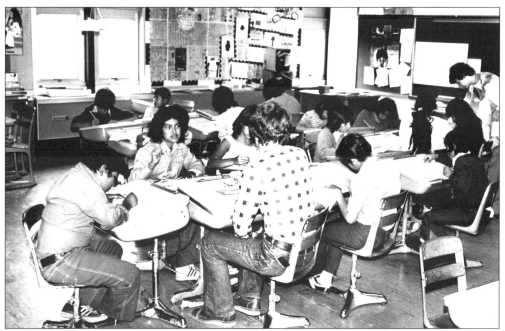

The Moorhead School District organized summer education programs for the children of migrant families. This photograph was taken in 1976 and the classroom was probably in Edison School. Several Mexican-American students who attended such classes later attended one of the colleges in Moorhead. (NMHC.)

In the midst of change, life's routines continued. The river, once a major artery of trade, had become by the 1970s a setting for leisure, a place to escape from the stresses of daily life. (Photograph courtesy of River Keepers.)

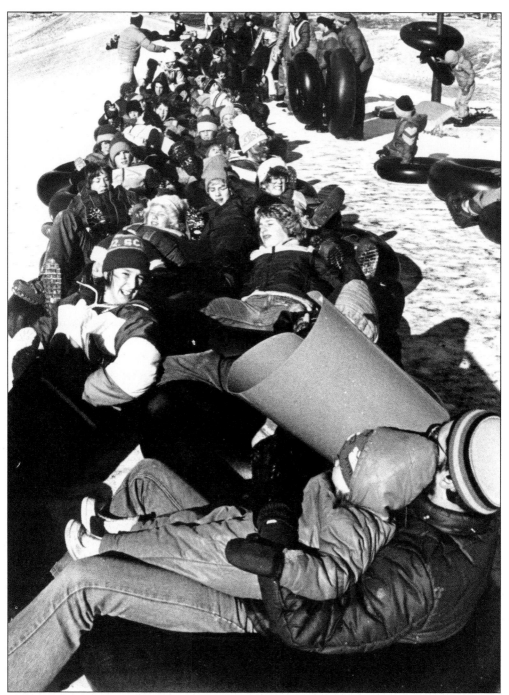
These 1970s children are sledding on the snow-covered dike along the east bank of the Red River. The dikes protected Moorhead from most flooding, giving many a feeling of security, a belief that the river could never again seriously threaten their property and comfort. Just 20 years later, the river would shatter such illusions. (NMHC.)

Nine
Ebb and Flow

In 1972, Moorhead celebrated the centennial of its founding with a series of celebrations that culminated in 1976 with the publication of a joint community history with its neighbor, Fargo. This, combined with the demolition of older downtown buildings during the urban redevelopment, triggered a renewed interest in the city's past. Moving into the 1980s, various official and ad hoc groups in Moorhead took steps to preserve the history of the community in a more systematic fashion. These efforts to remember the past played a significant part in the community into the last years of the century.

Late in the 1990s, however, the very existence of Moorhead itself was threatened when the Red River and its tributaries, swollen with the moisture of a wet autumn and a heavy winter, overflowed in the worst flood on record. For a brief few weeks in April of 1997, it seemed that Moorhead's story might come to an end.

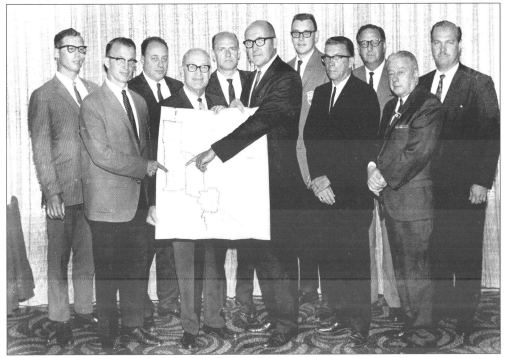

With the increase in leisure spending in and around the Minnesota lake country, Moorhead city and business leaders helped to create the Northwest Area Tourism Association to gain an edge in the competition for tourist dollars. Here, members of the association gather in Moorhead in the 1960s. (NMHC.)

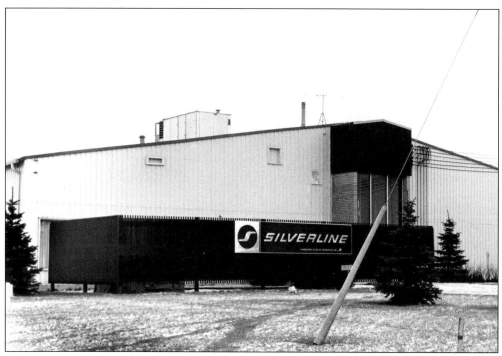

Continuing prosperity also was reflected in a number of leisure-oriented businesses. Silverline, a manufacturer of pleasure and fishing boats, was one of the light industries that did well in Moorhead. Silverline remained in business until about 1980, when its owner retired. (NMHC.)

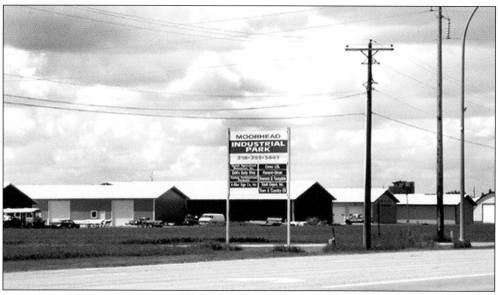

A large part of the light industry in Moorhead has been located in the Industrial Park. When it was first planned and developed, the industrial park was on the eastern edge of the city. But new neighborhoods of homes have since grown up around it. (NMHC.)

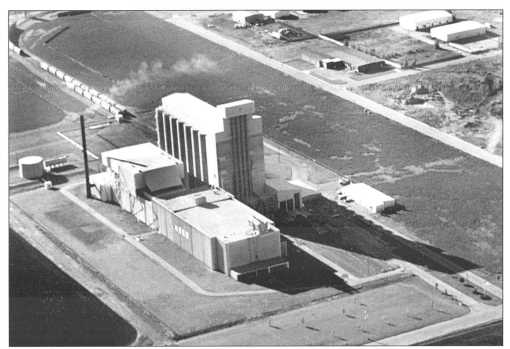

Anheuser-Busch Corporation built a malt processing plant within the Moorhead Industrial Park. To accommodate the plant, the city found it necessary to greatly increase its facilities for water purification and distribution. (NMHC.)

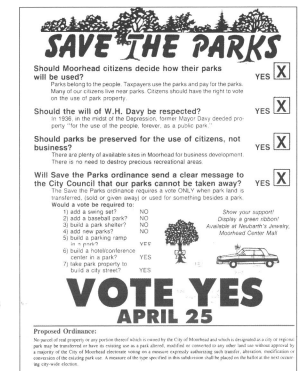

The growth of local industry led to debates over land use. When the city government began discussing proposals to build a convention center-hotel complex in the late 1980s, fears arose over the fate of the local parks. A citizens' group circulated this flyer in the 1990s. (NMHC.)

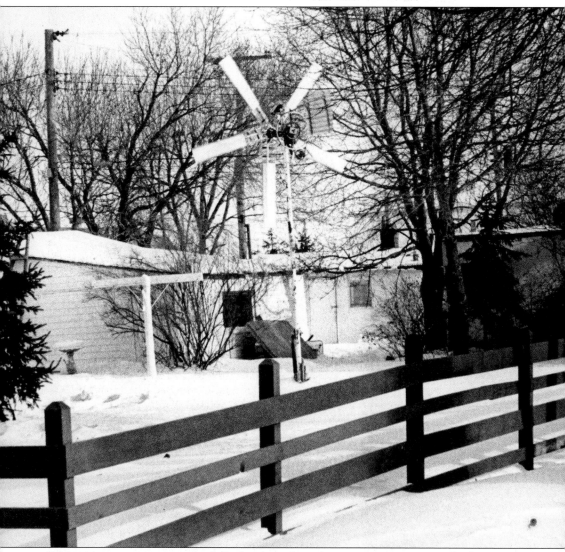

With rising power costs, some Moorhead residents began to experiment with alternatives in power generation. This early 1970s photograph of a Moorhead home shows a wind generator for producing electricity. The city of Moorhead maintains its own community electrical and water systems, although in actual practice most of the electrical power is purchased from large power generation facilities in the western plains. In the early 1990s, Moorhead's city government began investing in its own sophisticated wind generators for additional electrical power. (NMHC.)

This photograph was taken in 1936, when drought conditions left the Red River water level at an all-time low. Lack of rain over a three-year stretch in the 1980s lowered the river again and the problem sparked discussions over whether or not communities would have to ration water use in future decades. (CCHS.)

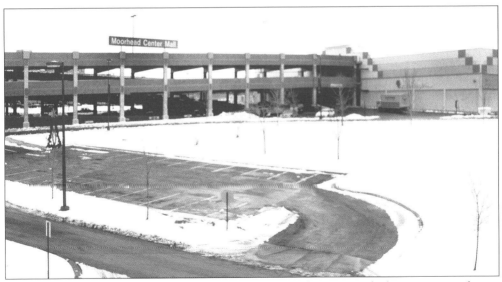

The Moorhead Center Mall received a facelift in the early 1990s with the expansion of some of the stores and more parking. The construction was undertaken in response to increased retail competition from neighboring communities. (NMHC.)

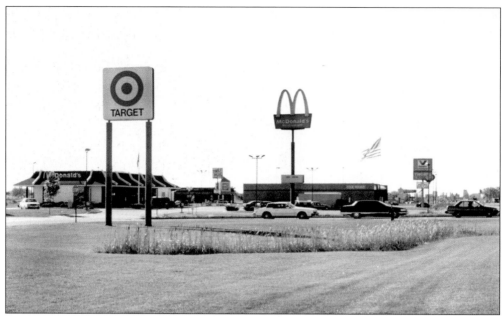

Popular brand name businesses have opened new franchises along the State Road 10 trade corridor that links Moorhead to its neighbor, Dilworth. Franchises added to the economy but placed greater pressure on family-owned businesses with a long history in the city. (Photograph courtesy of Moorhead Economic Development Office.)

Agriculture was no longer so great a part of the Moorhead economy, and the farming industry is itself adapting to new demands. The sign at the edge of this field south of Moorhead informs readers that this is an organic farm and that the use of "toxic sprays (is) prohibited." (NMHC.)

A student prepares blueprints at the Northwest Technical College in Moorhead, c. early 1990s. The technical school began in 1965 and continues to expand both program offerings and facilities to meet the increased need for career training. (Photograph courtesy of Minnesota State Community and Technical College, Moorhead.)

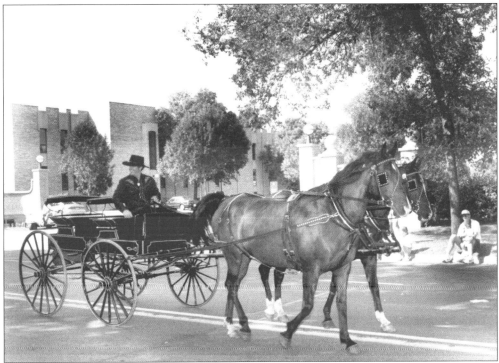

Continuing change has encouraged a feeling of nostalgia for earlier, simpler times. There has been an increased interest in the restoration and preservation of antique vehicles and other implements of the past. The main entryway of Concordia College can be seen behind this restored carriage on parade. (NMHC.)

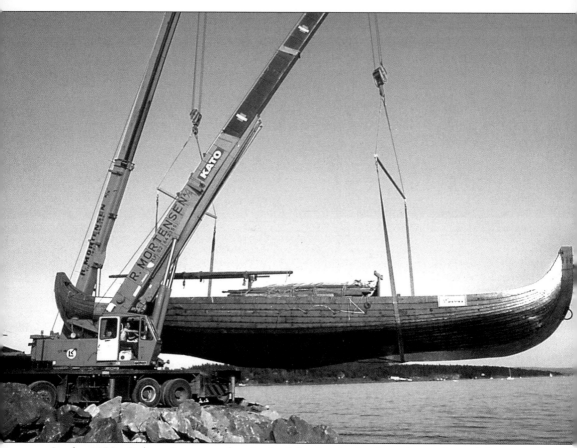

In the 1970s, Robert Asp, a teacher in the Moorhead schools and a student of the region's Scandinavian heritage, spent nearly 10 years building an exact replica of a 9th century Viking Long Ship. When Asp died soon after completing the ship and naming it the Hjemkomst ("Homecoming"), his children, with the help of friends, sailed it from Duluth, Minnesota to Norway in 1982. Soon after it was returned to the United States, a citizen's group in Moorhead began planning a museum for housing the ship along with historical records and artifacts. (Photograph courtesy of Heritage-Hjemkomst Interpretive Center.)

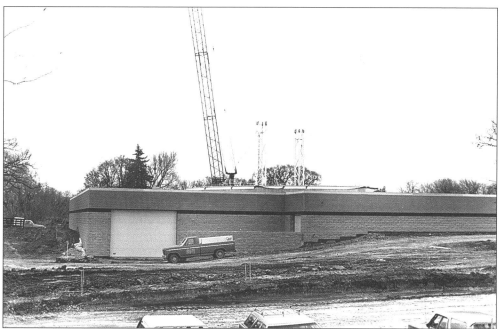

Construction work is underway for the Heritage-Hjemkomst Interpretive Center in this 1984 photograph. The building was completed and dedicated in 1985. The center houses the Asp ship, exhibits on the history of the Red River Valley, the Clay County Historical Society, and a senior citizens' community center. (Photograph courtesy of Heritage-Hjemkomst Interpretive Center.)

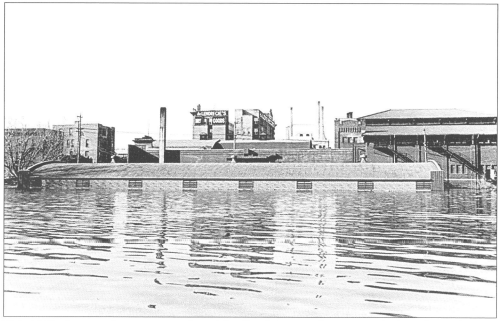

This 1943 photograph gives some idea of the flood damage that occurred when the Red River, swollen by a wet winter and early spring rains, overflowed its normal course. Despite extensive dike construction in the 1950s and 1960s, heavy winter snows produced a spring flood in 1997 that exceeded all previous records. (NMHC.)

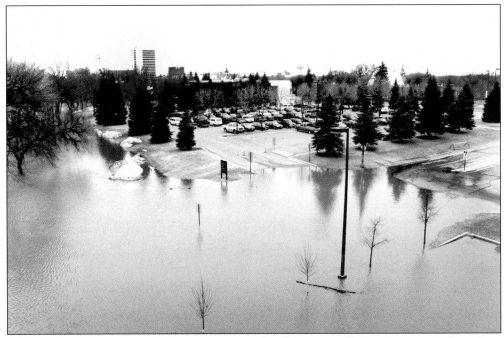

Taken from the top of the parking garage at Moorhead Center Mall, this photograph shows how close the 1997 flood came to inundating the corporate offices of the American Crystal Sugar Company. Had floodwaters risen another 18 inches, the downtowns of Moorhead and Fargo would have been extensively damaged. (NMHC.)

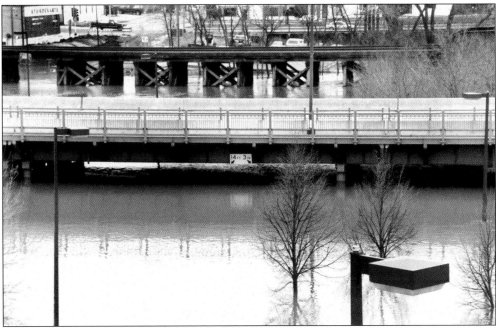

Normally, an open road passing under the Main Avenue Bridge (in the foreground) has a clearance of over 14 feet. But when this photograph was taken on the second day of April, 1997, the rising water was threatening to overtop the bridge and pour down Main. (NMHC.)

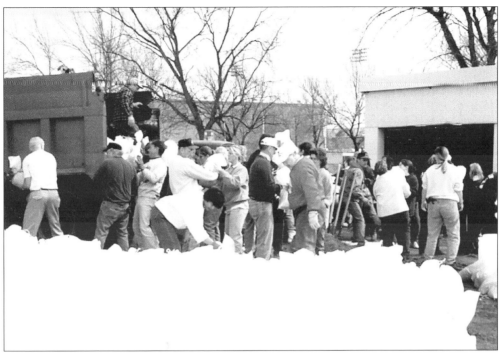

In this photograph, Moorhead volunteers fill and load thousands of sandbags for use around the city. Many more homes in Moorhead would have been destroyed in the 1997 flood but for these volunteer efforts, which were repeated up and down the river valley. (NMHC.)

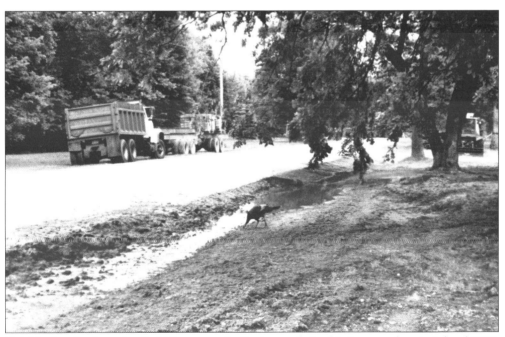

Neighborhoods along the Red River were badly damaged. In this image, taken in July of 1997, houses along this street in the far south of Moorhead were purchased and demolished to extend the dikes against a future disaster. Note the wild turkey in the center of this photograph. (NMHC.)

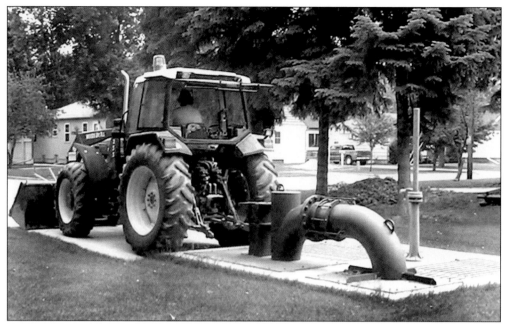

Further damage in Moorhead occurred when water threatened to inundate the city sewer and drainage system. The city subsequently added emergency pumps, powered by city equipment, and redesigned municipal golf courses to act as spillways in any future flooding. (Photograph courtesy of Moorhead Public Services.)

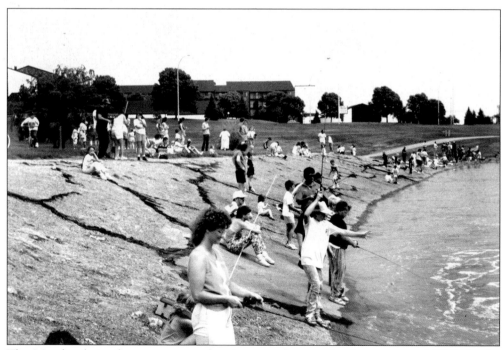

The Moorhead riverfront was restored to its normal course by the summer of 1997. In the future, citizens hope that the river will simply be a benign setting for canoe races, fishing derbies, and other community festivals. (Photograph courtesy of River Keepers.)

Ten
MOVING FORWARD, LOOKING BACK

Moorhead entered the 21st century a bit battered from the 1997 flood, but certainly unbowed. It did not take long for the people of the city to realize that entirely new challenges awaited their community. Like so much of the nation, Moorhead faces hard choices as its population ages and the birth rate declines—everything from new school construction to the future of the economy hangs on what the city will do in its planning. The 9/11 tragedy in 2001 only heightened the sense of uncertainty about the future.

This perhaps helps to explain why, in so many of the steps that the city is now taking for future community growth, there is present a palpable sense of Moorhead's past. As people face the unknowns of tomorrow, they look for reassurance in Moorhead's substantial heritage.

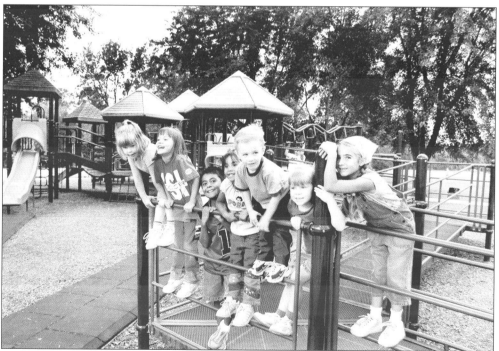

This image shows children at play in the refurbished playground of Gooseberry Mound Park in Moorhead in 2003. The park required major repairs after the 1997 flood. The population of children in the entire region has declined over the past decade, and new choices are being faced in such matters as tax revenue, childcare, and education. (Photograph courtesy of Moorhead Parks and Recreation.)

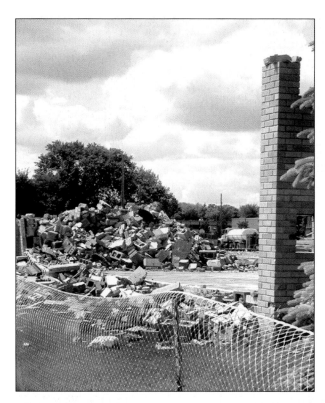

Voyager School began its life as the parochial school administered by St. Joseph's Church. After several decades in that role, Voyager was purchased by the Moorhead public school district and used as a "stop-gap" space for students while new buildings were being planned. Many mourned the demolition of the old school in the summer of 2003. (NMHC.)

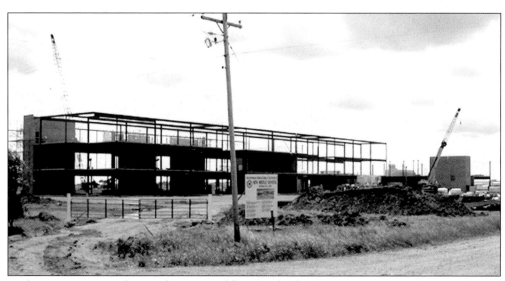

In the same summer of 2003, the new middle school (*above*) was being erected on Moorhead's east side. Many of the older schools are being closed, and this has awakened nostalgia for "simpler times." (NMHC.)

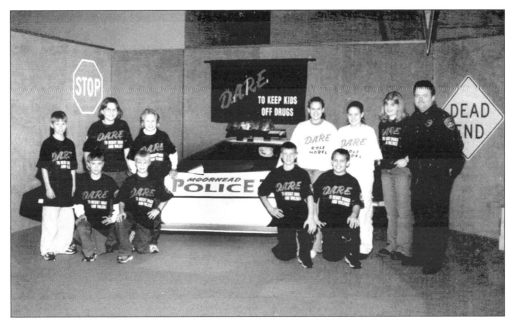

Clay County sheriff Bill Bergquist poses with students and the Moorhead Police D.A.R.E. car in this 2003 image. The Drug Abuse Resistance Education program has grown in rural areas within the past decade, and Moorhead has been no exception to this. (Photograph courtesy of Moorhead Police Department.)

Here, tenants exercise at Eventide's Linden Tree Circle in 2003. By 2000, almost 13 percent of Moorhead's population was comprised of older adults. Moorhead's demographic profile is changing, with consequent adjustments in housing, medical care, and recreation facilities. (Photograph courtesy of Eventide and John Borge.)

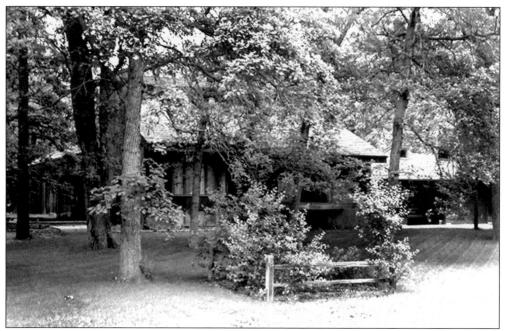

Many families have built homes in unincorporated areas north of Moorhead. Oakport Township, pictured above, is one such development. Much of this suburban area, including Oakport, is to be incorporated into the city in 2010. (NMHC.)

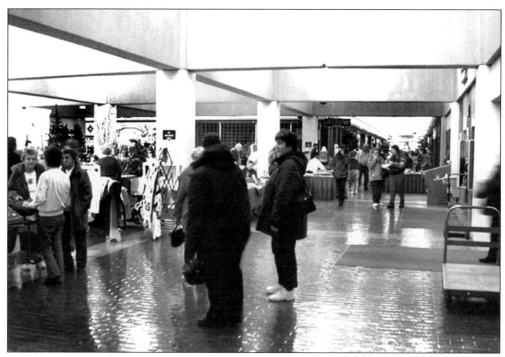

Moorhead Center Mall, once the centerpiece of business, now has to compete with newer shopping areas. The mall management now leases mall space to special sales organizers. Making the rounds at craft fairs, and collectibles and antiques shows, has become a weekend tradition. (NMHC.)

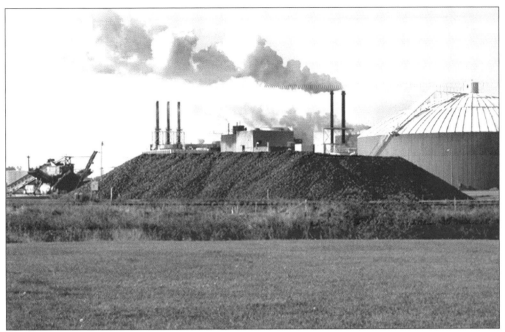

The American Crystal plant in Moorhead was extensively modernized in the 1990s, especially by the construction of refrigerated storage areas. The grower-owned company worries that recent international trade agreements could seriously diminish the profitability of the crop, particularly among smaller farming operations. (NMHC.)

In the early 1990s, Moorhead joined with Clay County in constructing an airport about three miles southeast of the city. In order to protect a nearby aquifer, all fuel tanks and other facilities were constructed above ground. (Photograph courtesy of Moorhead Economic Development Office.)

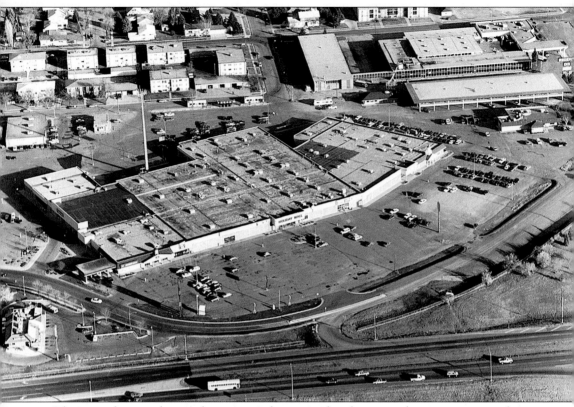

The two photographs on these pages show specific phases in the construction of a new development on Moorhead's south side, near Highway 94. In the spring of 2001, demolition began on Holiday Mall, one of the first shopping centers in the city. Also torn down was the closed hotel next to it (the hotel is still standing in the first photograph, in the upper right). Buildings that had been symbols of Moorhead's modern look in the 1960s are in their turn being replaced, in this case by a new hotel-conference center and a new mall. In the second photograph, taken in the spring of 2002, one can see that little remains of the debris from

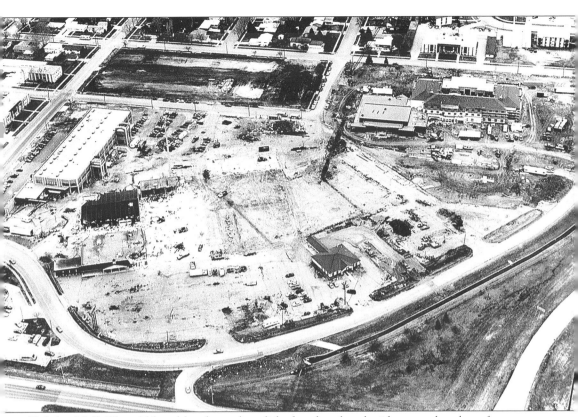

Holiday Mall. The old hotel has been demolished and replaced with a new hotel-conference center (upper right). The new mall (center left) is nearing completion, while a branch bank (center right, near the access road) is already in operation.

By early 2004, the hotel, a Marriott, had been in business for nearly a year. The mall's upper level contains offices for local businesses. But with the national economic slump, store leases for the lower level have been slow in coming. (Photograph courtesy of Wayne Bradley and Eide Bailly.)

As the population has changed, so has the power structure of the city. In 1988, Diane Wray Williams was the first woman elected by Moorhead to serve in the Minnesota Legislature. She served one term, and is currently part of the Moorhead City Council. (Photograph courtesy of Diane Wray Williams.)

By 2000, about five percent of the city's population was of Hispanic ethnicity. The 1990s saw a corresponding increase in community activities related to Mexican-American culture, in the case of this 1991 photograph, a workshop for local teachers on "Hispanic Cultures and the Red River Valley." (NMHC.)

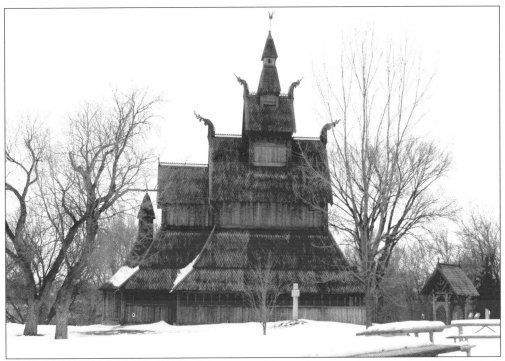

Other communities in Moorhead continue to celebrate their own heritage. In 1998, this full-scale replica of a Norwegian Stave Church (built of pine and redwood upon vertical posts, or staves) was dedicated on the grounds of the Heritage-Hjemkomst Center. The church features carvings that reflect "Christian and Viking-age motifs." (NMHC.)

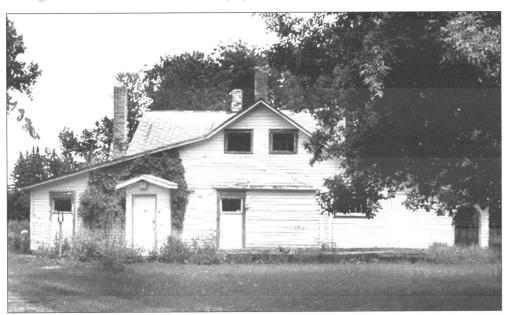

The home of Moorhead pioneer Randolph Probstfield still exists on its original site in the north of Moorhead. Built in the early 20th century, the house is part of a site being developed as a "living history farm." Fundraising for the project continues. (NMHC.)

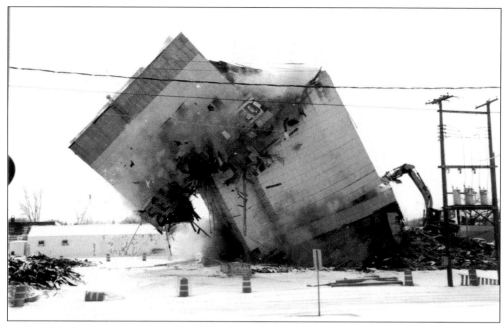

Old grain elevators, once a prominent part of Moorhead's economy, were demolished on Moorhead's First Avenue in February of 2003. The city is still considering how these lots will be redeveloped. (Photograph courtesy of Abby Sunde-Tow.)

Ralph's Corner and Kirby's, two taverns standing at the east end of Main Avenue, have been favorite community hangouts for several decades. Kirby's is part of the Kassenborg Block, a building erected in 1898. In February 2004, the city adopted a plan that will preserve and renovate the Kassenborg Block for new use. (NMHC.)

The Douglas House, built in 1872 by the first postmaster of the town, stands in poor condition on 4th Street. Some citizens want to preserve it, while others argue that the cost of preservation will be too high. The city wishes to save the house, if a "viable" commercial use can be found for it. (NMHC.)

In the early 1990s, Concordia College celebrated its centennial. The Campanile, erected in the campus center as part of the centennial celebration, has become the college's most recognized symbol. (Photograph courtesy of Concordia College.)

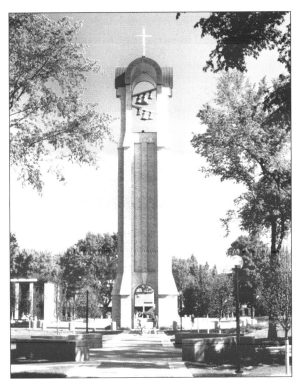

Faculty and students on the campus of Minnesota State University Moorhead gathered on September 11, 2003 to observe the second anniversary of the 9/11 tragedy. A number of college students and Moorhead residents have set aside their normal lives while performing military service overseas. (Photograph courtesy of Darel Paulson.)

Moorhead's experience came full circle in 2003 when the Main Avenue Bridge over the Red River was demolished for replacement. The foundations for a larger bridge are being constructed in this autumn photograph. To the right the still-used railroad bridge can be seen. It dates back to the 1880s. (NMHC.)